Some
Recent
Attacks

Essays
Cultural
& Political

James Kelman

AK PRESS

First printing 1992

AK Press
3 Balmoral Place
Stirling, Scotland, FK8 2RD
Great Britain

British Library Cataloguing-in-Publication Data

Kelman, James
 Some Recent Attacks: Essays Cultural and
 Political
 I. Title
 824.914

 ISBN 1-873176-80-5

Typesetting and design by Freddie Baer

Printed in Great Britain by BPCC Wheatons Ltd.

Table of Contents

for
Les Forster, John La Rose and Hugh Savage

Foreword

Early in 1990 I became involved with Workers' City. An article in the first edition of *The Glasgow Keelie* had said it was time those who held critical views of the Year of Culture should air them publicly or otherwise show solidarity with those who were. I thought this was fair enough and joined their picket of the opening of *Glasgow's Glasgow* — an enterprise which seemed to sum up the rotten core of Culture Year. There were around 20 people on the line, many of whom I was acquainted with, a couple were friends. It was raining. Eventually we broke for a pint and were interviewed by a guy from *The Spectator* who couldn't believe his luck — half a dozen of the picket had turned out to be writers. I later heard that a member of the city's Festivals Unit team, when asked why there was such a dearth of writers involved in the Cultural Celebrations, replied that 'writers were too difficult'.

The 1990 agenda, set by the municipal authorities, was fixed on a straightforward premise, that the European City of Culture was both an affirmation of Art and an affirmation of Glasgow: thus if you were opposed to the first you were opposed to the other two. So the Workers' City group was presented as an unpatriotic bunch of philistines, the ghost of Stalinist past and workerist future. By drawing attention to certain awkward realities we encountered a quite remarkable venom. There was little we could do about this. On one occasion the *Glasgow Herald* offered us a 'right of reply' and we took it but aside from that we were left in the usual situation of having to content ourselves with 'Outraged of Newton Mearns' type-letters to the editor. We decided to stay silent and concentrate on our own agenda, which included trying to remind people who had known us for years that we didn't hate Glasgow and we didn't hate art.

The name 'Workers' City' carries obvious connotations but it was chosen to directly challenge 'Merchant City', highlighting the grossness of the fallacy that Glasgow somehow exists because of the tireless efforts of a tiny patriotic coalition of fearless 18th century entrepre-

neurs and far-sighted politicians. These same merchants and politicians made the bulk of their personal fortunes by the simple expediency of not paying the price of labour. In the Caribbean they owned huge plantations and forced people to work on them for nothing. They were slavers. Those legendary heroes our children are taught to honour — Buchanan, Miller, Ingram and so on — were men who trafficked in degradation, causing untold misery, death and suffering to scores of thousands of men, women and children. Yet this myth is perpetuated by the present-day Labour authorities who see themselves as far-sighted and fearlessly donate financial and other inducements to the 'merchants' of the late 20th century. The personal wealth of those earlier individuals may have been founded upon slavery but the city of Glasgow wasn't, and its present-day citizens have to survive in spite of the current crop. The argument was put by the Workers' City group on numerous occasions and was dismissed as a kind of priggish idealism.

This double-think 'socialist' line can be seen in reference to other legendary heroes 'who . . . ' according to the journalist Ruth Wishart ' . . . unhesitatingly placed Glasgow within an international context'. She is speaking about shipping magnates like Stephens, Elder and Burrell, Yarrow and the rest. The iniquities faced by the people who actually had to work for these men is irrelevant. In fact the full legacy left by the farsighted shipping magnates is only now being realized, in the form of horrific absestos-related terminal illnesses, contracted by more than 20,000 shipyard workers since the last war alone, making Glasgow's death-rate from these diseases some eight times higher than the U.K. average (and that's the official figure). And the legendary heroes were well aware of the dangers, in other words they knowingly and cynically exposed tens of thousands of Clydeside workers to one of the deadliest substances known to humankind. Thus have the Leaders of the Labour Movement come to enshrine not those who fought and died on behalf of it, but those who were its uncompromising enemies.

While the Cultural Celebrations were taking place the Labour politicians and city officials were conducting a brutal and secretive campaign of victimisation against Elspeth King, curator of the People's Palace. A counter campaign was launched in Ms. King's defence. Though initiated by Workers' City it was supported by a very large, heterogeneous section of the Glaswegian public. This issue attracted more letters to the *Glasgow Herald* editor than any other news item since Billy Graham's mission to convert the city some 25 years earlier. And by far the majority of those letters were in defence of Ms. King. One contained the names of more than 50 writers and artists. All were roundly denounced by the

authorities. A 10,000 word document was issued which bore the signature of Patrick Lally, leader of the Labour Council. Those who supported Ms. King were variously described as a bunch of "misfits, dilettanti, well-heeled authors and critics; professional whingers, crypto-communists, self proclaimed anarchists, trotskyists" etc. etc. Hugh Savage, Farquhar McLay and myself were condemned by the Deputy Director of Glasgow's Festivals Unit (currently director of the Tramways theatre) as an 'embarrassment' to the city's 'cultural workforce'.

There was a lot of paranoia about. A Professor of German Literature published an essay on the literary works of myself and Alasdair Gray in the *New York Review of Books* and had the temerity to express his own criticism of the European City of Culture. The very next issue of this American literary journal contained a letter to the editor bearing the signature of Patrick Lally, stating that whereas the Professor thinks Culture Year a resounding failure 'everyone else thinks otherwise.' This kind of ludicrous behaviour was typical and perhaps the most important question to be asked of the Labour Party in Glasgow is not so much who wrote the letters and documents bearing their leader's signature but who paid for the stamps and materials?

In her defence of Culture Year (and the Labour Party) Ruth Wishart acknowledged that the Leader of Glasgow District Council was 'much accused' for his 'Mayor Daley approach to local government'. Her defence rests on expediency. Without Lally and his colleagues' 'robust pursuit of the project, and (their) consummate game of economic chess', lucky old Glasgow would not have a new concert hall. Apparently this is clear evidence of the success of 'the Mayor Daley approach' and is an answer to the critics. Needless to say the fact that so much of the money for this new concert hall came from the insurance company who paid up when the old concert hall burnt down some 25 years earlier was conveniently forgotten. Both the media and the authorities try to transform such leaders into cuddly uncles and aunties whose bullying and ruthless ways are an endearing anachronism. It's no accident that both Lally and Thatcher were enjoying their finest hours in tandem. And those who persisted in sniping at Uncle Pat — as with Auntie Maggie — were obliged to admit that at least he 'gets things done'. Fortunately he wasn't allowed to bring in the troops although at one point, during a protest *inside* the City Chambers (against the Labour group's proposed sale of a third of Glasgow Green to private developers), the 150 or so women, men and children who took part were surprised to find 50 uniformed policepersons waiting downstairs in the lobby.

3

What the Labour Party — and the establishment generally — cannot countenance is criticism, freedom of speech and expression, which is why they exercise censorship and suppression to such excessive lengths. When citizens of Glasgow argued for the right to remain separate from Culture City 1990 they were also arguing for the right to disassociate themselves from a decision that was made on their behalf but over which they had absolutely no control.

The Labour leadership and their sympathisers were correct to see the attacks on European City of Culture as an attack on themselves. Activists on the left have always had to fight the leadership of the Labour Party. Optimists have worked to change it from within. Others have remained without, preferring not to be incorporated into its reverberating assembly line of cutting tools and hammers. Like Scotland as a whole the people of Glasgow have given the Labour Party a mandate for a long number of years. In exchange for this mandate its leadership has demanded solidarity. They always demand solidarity, urging the people of Scotland to ignore these fringe-type crypto-radicals who persist in fighting the Tories instead of siding with themselves in their fearless struggle to implement Tory policy. Nowhere has this been more evident than in the fight against the poll tax. And the endemic hypocrisy of the Labour leadership is perhaps epitomised by Charles Gray of Strathclyde Region who expressed his concern that the police were being too lenient with anti-poll tax demonstrators out protesting the attempted warrant sale of a family's household goods, reminiscent of Kinnock's outrageous comments during the miners' strike of 1985.

The parliamentary opposition parties are essential to the political apparatus of this country which is designed to arrest justice. People were outraged by what occurred in 1990 in the name of culture and continues to occur now in the name of democracy. The victimisation of the curator of the People's Palace and the millions of pounds lost in the *Glagow's Glasgow* temporary exhibition symbolized the corruption of Culture Year. The horrible bit about it is that it was so predictable. And it's a measure of the U.K. political apparatus that so many of us were so powerless to stem the sewage. Most of the essays contained here were written for talks I was asked to give during that period and the year following: the reader will see some repetition but will appreciate that this had to be the case

James Kelman
May 1992

4

Artists and Value

[written for a talk to the MA students at Glasgow School of Art in early 1990 or late 1989]

For some people part of the romance of being a writer can lie in how this actual opening sentence is being composed, it is 3:10 A.M., alone in my room, everybody else asleep, the big city at night etc. etc. And only a week before the talk is due to be delivered. But there's the other side to it: there's just *enough* alcohol in my system, not enough to knock me out, plus I've got a sore back, so that's also how come I'm up and writing at three o'clock in the morning. Five hours ago I was leaving the pub, then bumped into somebody who said he was going to try to be here today, so me remembering I still had it to do, that I'd better get down to work immediately.

This can be a dangerous period, what some artists regard as a bogey period, these solitary hours of the nightshift, the kind of intoxication that leads to guilt-ridden anxieties — usually about the amount of time you spend away from your work, how lazy and fraudulent you really are. And these attacks of conscience can degenerate further and further, with much of the night still to get through . . .

In Hollywood pictures the artist as hero — and it's usually a hero and never a heroine — and this hero who is not a heroine is either a single fellow or else the woman he is involved with is going to turn out to be a bad yin — a bad yin, because then this dashing masculine male will have the absolute right to go off and sleep with anybody he likes, but most especially the beautiful young lassie from next door, without any moral guilt whatsoever.

At university as a mature student — I went when I was 28, a married man with two kids — at university as a mature student I did philosophy, including a course on logic, and I think this has

5

helped me cope with the occasional difficult proposition. A proposition is just a statement; and any statement may or may not be true. A wee bit of logic can occasionally help you in this way: instead of having to say what something is, an artist for example, instead of saying what an artist is, if ever you're being forced to define such a body, you just say what an artist is not. When in doubt negate, turn your yes into a no, your positive into a negative. The writer Franz Kafka — by the way, whenever I refer to **artist** I don't mean someone who is a visual artist particularly, I am referring to writers and musicians and dramatists and painters and sculptors and maybe dancers and actors, and so on — one thing you can notice in Franz Kafka's work, most particularly in his use of third party narrative, he doesn't necessarily detail a thing that exists. What he often does is refer to a space which he then fills with a crowd of things that either don't exist, or **maybe** don't exist. He fills the page with absences and possible absences, possible realities.

Who is that woman! She isn't my wife. She isn't my fiancee. And she isn't my girlfriend. Nor my sister. She isn't my grannie nor yet my mother. And she probably isn't my auntie and I doubt if she's my cousin. Who is she? She isn't my neighbour. She maybe isn't anyone I know at all. Probably she's a stranger. She isn't big and she isn't wee. But she isn't really medium sized either. And her hair isn't blonde and it isn't brown and nor is it black. But it isn't grey and doesn't even seem to be white, and I'm sure it's not red! Her nose isn't big, but nor is it wee, and her eyes aren't blue and not even green nor brown. She doesn't wear a coat and she doesn't wear a hat and her dress isn't long but it isn't short and she's not holding a bag and doesn't look like she ever does hold a bag, and nor does she look like . . . And so on.

In talking about this technique critically you could use the terms 'negative apprehension' and 'the subjunctive mood'. Other artists apart from Kafka use the method. And central to its use is something extremely political, something extremely subversive: by the very application of this literary technique, or artistic method, entire value systems can no longer be taken for granted, they become problematic, they are open to question:

The big man entered the room. What size is he? He's 5 foot 9 inches. Where am I? Am I in the clubhouse of an exclusive golf club, at a social gathering of Young Farmers, dining at the Rotary

Club, drinking real ale in the Students' Union Bar at Glasgow University? 5 foot 9 inches.

Heh big yin!

The big man entered the room. What size is he? He's 6 foot 9 inches? Where am I now? Am I in a pub down the Gallowgate, Glasgow? am I signing on at the broo, waiting in the queue at the Income Supplement enquiries counter, standing in the dock of the Sheriff's Court? — not standing in the dock, definitely. But *judging the fate of* the man in the dock? maybe.

Writers are literary artists, they write stories, they tell tales. A storyteller is somebody who tells tales. It is important to appreciate that stories cannot be true and they cannot be false: they are fictions; and you cannot get true fictions and you cannot get false fictions; they just exist; stories just exist. They are created by people; an artist is a person.

Here is a tip on technique generally: when you work your way through every absence you can think of you'll be left with a particular, something concrete; and this is usually where you discover the finest art, or at least the most satisfactory. But that is only an opinion, my own.

And also as a postscript I'm afraid most technique is metaphor.

Bearing in mind that any proposition, or statement, can be true or false, here are four of them:

A good writer is not necessarily a good person.

A good writer is not necessarily a good artist.

A good sculptor or painter is not necessarily a good artist.

A painter or sculptor who has never ever gone to art school might be a major artist.

Someone who paints or sculpts and has spent every working day of her or his life in an art school might never discover what art is, let alone become an artist, although it is possible the same person could one day discover what art is *not*.

When I was at Strathclyde University I became uneasy when a writer I didn't think deserved to be called an artist was being described as 'good', and sometimes even 'major', by the lecturers. Even the very fact that you were given such writers at university meant they were *assumed* to be 'good'. The lecturers and university authorities hold the power: they can say something is good without having to prove it. If you, as a student, want to deny that some-

thing is good then **you** are forced to prove 'it'. And proving anything is never easy. Atheists in the company will know what I'm talking about: it's never the person who actually believes in God who has to find the proof, only those who don't. Proving something doesn't exist can be every bit as hard as proving something does exist. In fact it's harder, often impossible. Anyway, at university I felt that if certain writers were going to be described as artists then something smelled about the very concept itself: *art* was just not as great as it's cracked up to be. So I wanted to distinguish between writers who were artists and writers who weren't artists. And in this context, if I'd been a student here at Art School, I might have wanted to distinguish between folk who were 'painters' or 'sculptors', and those who were 'painters or sculptors but also 'artists'.

But sticking to the literary arts, take for example the poet T. S. Eliot or the novelist Evelyn Waugh. Evelyn Waugh seemed to me to be so right-wing you'd be forgiven for calling him a fascist. And how could you call a fascist an artist. That struck me as by way of a contradiction in terms. So I wanted to say: here is a writer who okay might be 'good' but either s/he is a bad artist or s/he isn't an artist at all — because surely someone who is a good artist cannot be someone who hates people of a different coloured skin, who hates people that speak a different language or whose racial origin differs from his own; surely a good artist won't be somebody who hates people of a different religion, people who come from a different cultural or economic background, who are not heterosexual, not homosexual, whatever.

But at that time I wasn't aware that so much of this business of the 'good' in literature, at least as it applies in education establishments, starts and ends with things like grammar and punctuation; in other words, if a lecturer calls a writer 'good' it might just mean the writer in question knows how to use semi colons and paragraphs in a certain manner, or has a very large vocabulary, or uses a great variety of rhetorical devices, or exhibits a certain educational or cultural background, or shows a wide knowledge of foreign words and phrases. And all of that sort of stuff wasn't what good writing should have been about, as far as I could see, and certainly not what good art was about.

One thing you do find is that many writers who are described as 'good' aren't that good at all, not when you examine their work

closely — often you don't even have to do it closely. Sort through the clumsiness and carelessness; the cliches, the shopsoiled phrases, the timeworn description; basic technical stuff. What it usually signifies is a straightforward lack of interest in, or awareness of, particulars. They don't reach the concrete. They seem content to give a general idea of something. Big handsome men and slender beautiful women will always be seen as such no matter who is doing the looking. And by quick extension of that:

Everybody on the broo is lazy. Jews are greedy. Black people are criminals. Red haired people are bad tempered. Irish people are ignorant. Peasants are hamfisted. Glaswegian working class males are drunken wife-beaters.

What is a cliche really but a conventional way of looking, a conventional way of perceiving. What do I mean when I use a term like 'shop soiled' or 'timeworn' or 'hackneyed', I really just mean secondhand perception and imagery. Writers who use too many cliches or timeworn phrases or shopsoiled figures of speech either just don't care or they're being lazy. Instead of thinking and judging for themselves they're relying on conventional wisdom, received opinion; the everyday values of society. And society is capricious; not only is it capricious, it is subject to control by those in authority.

If you criticise or condemn a long-dead writer or a long-dead painter, or politician, or philosopher — anybody at all in fact — if you condemn them for being racist, or sexist, or elitist, or bigoted in some other way, you get told you have to see the person in her or his own historical context. (Or else, of course, you get told just to 'prove it'.) Some of you may know of a recent controversy featuring the Nigerian writer Chinua Achebe. He described Joseph Conrad as a thoroughgoing racist and was attacked for it by, amongst others, Blake Morrison, a poet and critic who reviews current writing for mainstream media outlets. Now, quite simply, Blake Morrison is prejudiced. There is just no question that Joseph Conrad was a racist. And the onus of proof is not on me, just as it wasn't on Chinua Achebe. Racism is one of the necessary tools for the march of imperialism, one more instrument of control, not just a hundred or so years ago but right now if we think of conventional American wisdom's use of terms like 'gook' and 'wetback' etc., or Germany's rules on citizenship, or the last census form issued in this fine upstanding country of ours where ethnicity applies only to people

who are not white. So in Conrad's day it was demanded by Empire, by capital and big business generally; intrinsic to western affairs of state whose control was 100 percent total, unlike just now when such glaringly obvious moral discrepancies are brushed under the carpet of Western Civilisation, with its capital w.c. But in Conrad's time any aspect of society which was NOT racist, I mean during the Victorian period when we were consolidating the heroin trade in China and just prior to when the U.S. was committing genocide, killing some three million women, men and children out in the Philippines, any aspect of western society that was not racist, is worthy of mention.

And that applies equally to writers and to painters and so on. And critics who recognise that an artist of a particular time and place was not racist etc. should be able to say so, not by how the person acted in private life but by a process of critical analysis. Such a person might well have stood out from the crowd through her or his social eccentricity but that's a side issue, the important distinguishing feature will be the originality of her or his perception:

Was Paul Gauguin racist? Was he sexist? What about Van Gogh, was he racist? Did he hate atheists? What about Picasso, was he sexist? Did he hate homosexuals? Was Gertrude Stein elitist? Did she hate men? These sorts of questions are also the province of art criticism. They cannot help being part of it.When we are examining the racial or sexual or elitist stereotypes in a writer or painter's work, we are examining technique.

At one time any cliche you care to name was a bold and original expression. But over a period of time all bold and original expressions become shopsoiled. They get worn by time. They get used too often by too many people in too many lax and indifferent ways. They lose their meaning, their reference becomes vague, obscure. Language shifts and moves, it is not static and neither is it finite. As a writer language is my material in a way that it rarely is for ordinary language users; I am attuned to it, or should be attuned to it, in ways slightly different from and possibly more sophisticated than the average user, it's a *reflective* pursuit. For instance, I should be able to recognise a cliche a mile away. But this will apply across the board, any painter or sculptor or musician should be able to spot a cliche in the media they work in; and they should be able to do so by exercising critical judgment. In the early stages of their work this judgment may be intuitive but sooner or later it should be otherwise. Take a closer look at some of the recent

crop of representational work being done in the visual arts. How much of that is cliched, stereotyped; conventional images of socially acceptable and socially conventional values — even where these values might be appear to be not right-wing because they *represent* the so-called working classes, the proletariat. They still bear the hallmarks of convention, of a generally-held view or opinion.

What actually is the proletariat? Or for that matter the bourgeoisie? How do you recognise a class of folk? Or a race of people? You recognise them by general characteristics. When we perceive a member of a class we are not perceiving an individual human being, we are perceiving an idea, an abstract entity, a generality; it is a way of looking that by and large is the very opposite of art. Artists should be able to look at what they do and know when it is not wrong, they need to value things for themselves — especially their own work. They have to be able to judge when it is correct and when it is not correct. If they rely on the critical judgment of society they would be as well to stop studying art and get onto a course in business administration, or accountancy if they're feeling optimistic. So much guff is spoken within our society about what is right and what is wrong that you have to be able to spot it for yourself. The mainstream media is morally bankrupt. It isn't up to me to prove it. When individuals employed within it act with integrity they stand out in sharp relief; they are exceptions, and exceptions always indicate a general rule. It isn't so much we are told downright lies — although very often we are — just that we are not told the truth, mainly this is done by negation, We are told what is not the case, either that or we get told nothing at all; we are given an absence of information, an absence of truth, we are given silence.

If you want to find out what's really going on in the world and your information comes via the mainstream media, you should restrict your reading to the business and financial pages. If there is any honesty left in the newspaper industry this is where you find it. It is also where you can find contemporary art criticism: I was reading the financial section of *The Guardian* the other day; Charles Saatchi of Saatchi and Saatchi, noted connoisseur of fine art, the chap hired by those great patrons of the arts and artists, Glasgow's Labour-controlled District Council, to advertise the Year of the City of Culture, he had just moved out of New York painters into British painters. In so doing he increased his profit 15 fold.

But greater sums of money are perhaps spent on paintings bought in the fashionable New York galleries than anywhere else in the entire galaxy. See that artist there! He's great! He must be great, his paintings sell in the fashionable New York galleries. He must be one of the greatest painters in the galaxy.

In our society it isn't only works of art which have a value placed on them by external forces, so do the actual creators themselves, the artists. The value is economic although it occasionally attempts to masquerade as aesthetic, and received wisdom brooks no distinction.

The creative output of most artists has no economic value at all. Nobody buys it and the names of the artists seldom get mentioned. Their work is 'worthless' and they are 'worthless'. And often when they are forced to earn money they earn it by teaching folk to do what they are being stopped from doing themselves.

How do we tell if an artist has value? We don't. Let somebody else do it. That sort of question is a red herring. We can tell if a *person* has value. And that value is moral if we want it to be moral. Or monetary, if we want it to be monetary. We can tell if a person's work has value. We can also tell if our own work has value. And if we are involved in an art medium then we evaluate this work on its own terms and these terms are aesthetic.

But even here critics and arbiters of art must understand the need for caution, that all technique is metaphor.

But one way I used to have of intuiting a painter from a painter who was also an artist, was how they treated the servants, how they treated the folk who work behind the bar in the Art Club, the folk who serve the grub down in the refectory, the ones who carry the pictures up the stairs and hang them. I was a delivery man of Fine Art. Myself and another guy had a transit van — I'm speaking now of about three years ago at a time when I wasn't earning enough as a writer and having to go beyond my own work to earn a few bob. I had a wee bit of early experience in the trade. My old man, and also my uncles and my grandfather, were picture framers, gilders and picture restorers. Myself and my brothers used to have to carry large framed, glazed paintings from where the Shish Mahal now is in Gibson Street all the way along Woodlands Road and old Charing Cross to around where the Mayfair disco now is on Sauchiehall Street, as well as to other small gallery type

shops in the area. It was a tricky business for a twelve year old boy
— huge pictures of naked people, ninety nine and a half percent of
whom were **not** men. Fortunately the old man draped army blan-
kets over them to defend our honour. I've always wondered if the
actual people who painted the pictures would have thought of that,
of draping the paintings to safeguard the modesty of the delivery
boys. It doesn't matter whether 'modesty' is right or wrong in the
circumstances; the only important point is whether or not the folk who
paint the pictures see it as an issue: to do so means seeing the servants
as particular people, individual human beings.

And back to three years ago, as a transporter of pictures for
various painters and galleries and exhibitions, I was reminded of it,
standing between two so-called artists in a lift, me balancing the
painting while they had a smoke and a blether. The concept of
'invisibility'. I knew from the conversation that it wouldn't have
crossed their mind that the chap carrying the picture could under-
stand what they were on about. They saw themselves as 'artists'.
The chap who transports their work was the chap who transports
their work. They have an inner spiritual life. But the chap doesn't,
the chap is a pleb, a servant, brutalised. Servants may be heroic or
not heroic but they're never fully-formed human beings, never
particular people. And if I had spoken, and revealed my ability to
take part in a heady conversation concerning **aesthetics** why then I
would have been an exception, I would have reinforced the rule:
some of my best friends are black. As far as art criticism is con-
cerned the heroic pleb is found in the work of social realism and
romance, the unheroic pleb isn't found in the work of social real-
ism, although can be in romance. But they all deal in stereotypes.

If a painter doesn't see what's under her or his nose then she
or he is odds-on not to be any bloody good — maybe that's an
exaggeration — but it certainly is odds-on that she or he will deal in
generalities, stereotypes and cliches; their work will reflect conven-
tional social value, received wisdom.

Roughly speaking the process of art is an aid to the purifica-
tion of society. Think when painters began observing and repre-
senting actual people on the canvas or page, as opposed to soulful
embodiments, the leap away from religious imagery, when the
virgin mary and the female saints began to look like women, when
christ and the male saints began to look like men, with all their

13

attendant physical blemishes. This at least as perceived by men of a certain social background; the female subjects might look like lovers, friends or relations of the male painter while the male saints would look like lovers, friends or relations of — or self portrait of — the male painter himself. And much later an examination of other stereotyping would occur and the crucified christ and madonnas and saints would start looking like social outcasts; diverse targets of conventional prejudice; servants and plebs, peasants, pakis, yids, whores, tims, niggers, wops, queers — even strangers, referring back to Conrad, racism and historical context, there's a verb in Classical Japanese if I remember correctly that means "to test one's new double-handed sword" and if you were a Samurai warrior this testing entailed going with the new double-handed sword to the outskirts of your village and there awaiting the first stranger. And when this stranger arrived you jumped out and split him from top to bottom, right down through the cranium; if you managed this in a oner it meant the sword was good and you went back and gave the swordsmith your compliments. The language itself indicating the horrors of that particular value-system, just as the use of the term 'gook', or 'grunt' indicates the horrors of another. So within the process of art more and more human beings start being 'discovered' as particulars, witnessed as individuals, specific folk, persons; and within the process of society more and more human beings start making such discoveries themselves, and in the far-off future there won't be any racism, no sexism, no prejudice, no imperialism, no colonisation, no economic exploitation, and so on and so forth, a process of elimination.

Usually if there are any real critics in the vicinity they will pin point where it happens in the work of artists; writers, painters and musicians, sculptors etc.; they will look at the work of any painter, of any school, and be able to judge its merit and to do that they can only begin by peeling away the layers and layers of convention, received wisdom.

At one time the derogatory terms used earlier would not have been derogatory at all. You could have used such words in polite, not to mention impolite, society and nobody would have thought anything of it. And the people who were offended and reacted in a hostile way would have been unconventional, eccentrics, social misfits (as artists are often designated) they would stand out. That

applies to the people the derogatory terms referred, as well as those who were offended by the use of the term. But there again, if you did happen to be a peasant or a paki or a darkie or a queer or a paddy or a yid or a woman, then the likelihood is that you wouldn't be there to be offended anyway — even metaphorically like the poor old servant who has to walk about with earplugs. For such groups of people wouldn't have been found in society. They are marginalised, confined below stairs, kept out of reach in a housing scheme, stuck in a closet, on a reservation, a homeland, a ghetto, an inner or outer city slum, whatever. And when you were standing there in some particular company, the servant or chap who carries the painting, you wouldn't be there, no one would 'see' you, that concept of 'invisibility' again.

Another side to the romance of being a writer, on how things are written; I went back to bed at 6 A.M. that Tuesday morning when I first started writing this and it is now two weeks later and this is just one more 'final' revision — although that in itself is a myth.

Thanks for listening.

English Literature and the Small Coterie

There was a long six month gap between publication of *The Satanic Verses* and the *fatwa* issued on its author by the Ayatollah Khomeini, prior to which the book had been suppressed in India, then Pakistan, Sudan, Indonesia, Egypt and other predominantly Muslim countries. During this period people within the Muslim community here in Britain had also been agitating, they had been holding meetings and they had been demonstrating; the outrage felt by so many was out there and it was not being concealed. Very little coverage was given them by the national media. But the Muslim community are accustomed to the lack of national media attention, especially *positive* attention. The growing incidence of racist violence is the main issue that springs to mind here; in 1988 alone statistics revealed by the Policy Studies Institute showed 70,000 racially motivated incidents were reported in this country; and an estimated 30,000 racial attacks occur annually. How many racist murders have been given press and television coverage during the past few years? How many newspapers reported on the extraordinarily brutal killing of Kuldip Singh Sekhon in London some time back (August 1989)? Or the more recent murder of Tasleem Akhtar, an eleven year old Birmingham girl? Or the death of the ten month old baby as a result of an arson attack last December? Or the murder of Ahmed Sheikh in Edinburgh a year ago? As far as the continuing protests over Salman Rushdie's novel is concerned it was the 'book burning' in Bradford that finally made the headlines.

Yet when Anthony Burgess states that 'book burners in Britain shame a free country by denying free expression through the vindictive agency of bonfires' you have to wonder if he is engaged in satire. This continual reference to Britain as a place where freedom of speech and expression exists derives either from ignorance

or a form of intellectual myopia, or else it is an attempt at distortion, a misrepresentation of the facts. It is possible, of course, that he was simply being imprecise, and was referring to works of English literature *in general*; but on such a sensitive issue, if he did intend that he should have said so. It is true to say that within the pages of poetry and prose fiction free expression can still exist, and it must continue to be fought for every time the possibility of censorship or suppression occurs, even although in certain instances the battle is technically lost, e.g. *Spycatcher*, or the blasphemy case brought by Mrs Mary Whitehouse against the writer James Kirkup.

But within English literature itself censorship and suppression exist already, and have done for several hundred years at least, and in much more subtle ways than the straightforward banning of books, as anyone who reads the 'forgotten' poets collected in Tom Leonard's *Radical Renfrew* will testify:

> In fact the spread of the right to vote in Britain
> paralleled the spread of the right to literacy, in that
> both were allowed within formal codes whose names
> acknowledged the supremacy of the status quo which
> must not be challenged: Her Majesty's Government,
> Her Majesty's Inspectorate of Schools, the Queen's
> English. The rights and values of monarch and
> aristocracy were sown into the definitions of what
> the people's new entitlements to personal expres-
> sion actually were.

Perhaps the one issue the debate around Rushdie's novel still continues to highlight in this country apart from the racism now rampant, is the pathetic state of contemporary literary criticism, certainly insofar as it relates to the public at large.

At the time I was given a book to review which is concerned with the issue generally, written by a freelance journalist and broadcaster, a man 'educated at Eton, Trinity College, Cambridge and the Middle East Centre for Arab Studies in the Lebanon'. He also happens to be 'the Visiting Professor of Religious Studies at Dartmouth College, New Hampshire'. I do not recommend this book. Its title alone (*A Satanic Affair*) can serve to indicate the author's bias, but for those

who want to browse first and make up their own minds here is a sample from the so-called argument:

> *The Satanic Verses*, a brilliant, playful, transgressive work that explores and parodies the very ingredients of Indo-British Muslim identity, mixing fact with fiction, history with myth, trod on most of the sensitive spots in this brittle collective ego: the integrity of the Qur'an, the sexuality of the Prophet Muhammad and his wives, the Mothers of the Believers. The majority of the British Muslim community exploded into rage — all, that is, but the tiny portion of it represented by Rushdie and a small Anglo-Indian coterie, most of whom had been educated at exclusive institutions where they had become fully assimilated into British society. For that vast majority of British Muslims, unaccustomed to the conventions of contemporary fiction with its rich and varied ingredients, Rushdie's riotous post-modernist pudding proved highly indigestible.

Like many other folk I would probably have come to read *The Satanic Verses* in my own time and was resisting having to read it as any sort of obligation. Now that I have read it I have no difficulty at all in describing it as a good novel. I doubt if it is a great one but within a certain literary context it could prove to be. Rushdie's ambitions are high and he can write very fine prose indeed; at times he can also be very funny. There are other occasions when he writes bad prose; and ultimately he is not successful in dealing with the problems of time and space, and in terms of the novel's structure this is vital. On that count alone it is difficult to speak of *The Satanic Verses* in the same breath as the work of James Joyce which is what some critics appear to be doing. Yet problems of time and space beset most writers of good prose fiction and when I see this demonstrated in a text it usually signifies literary merit.

But anyone who relies so heavily (Rushdie would argue intentionally) on the 'technique' of stereotype is always flirting with danger and much of the novel fails as a result. By definition this 'technique' offers a simplistic view of people and situations

that is always conventional, a recipe for lazy writing. At worst it becomes prejudicial and serves only to reinforce the marginalisation of distinct social groupings. It does this by destroying a person's individuality through its tacit acceptance of the prejudiced view that all so and so's are this, that or the next thing. In contemporary British society everyday examples of stereotyping include the following: scroungers are in receipt of DHSS benefit; trades unionists are whingers; the Irish are terrorists; foreigners are suspect; blacks are anti-social; Jews are conspirators; homosexuals are unclean child-molesters; rape-victims are provocative; the entire British Muslim community is ignorant — except for 'the tiny portion of it represented by a small Anglo-Indian coterie, most of whom have been educated at exclusive institutions and are fully assimilated into British-society': and so on and so forth.

In a literary context one of the limited ways of using the stereotype technique creatively is to turn a prejudice on its head: the 'stereotyped' character is then revealed as an ordinary human being, with the specific qualities thereby demanded. Here the author of *The Satanic Verses* seems to me to fail too often for comfort and a case for 'insult' if not 'outrage' might conceivably be made by Afro-Carribean black people, white working class people, people who have never received the benefits of higher education, people who 'do not speak properly' and people who look 'rat-faced' or 'piggy'. The work therefore contains a number of the stock characters and situations any politicized student of the English literary canon is well used to, and it places the novel in this mainstream. At schools and colleges and universities, in general, our students are taught *not to question* that such is the stuff of art. And if we genuinely demand free expression in our society then such stuff very often will be 'art'. It is within these terms that *The Satanic Verses* can be described as a good novel; perhaps ultimately, some would say, even a great one.

The critical context in which the public debate should have been set initially in Britain at least, is literary. Apart from those who have described the novel as 'excellent' 'major' 'terrific' 'important' 'boring' 'bad' 'unreadable' etc., very little was heard from the literary establishment apart from spurious stuff to do with need to protect 'freedom of speech and expression'. This unwillingness or inability to examine the work in public is nothing short of pathetic.

Yet it is quite understandable and not at all surprising. By implication such an undertaking would have been to examine not only the very ordinary human prejudice of the critics themselves, it would have been to expose the endemic racism, class bias and general elitism at the English end of the Anglo American literary tradition.

A socially responsible approach to literature could have happened a hundred or more years ago. On the whole it has never happened at all. In terms of the present controversy it strikes me as of sociological interest that similar situations have not occurred more frequently. This is not to underestimate that particular aspect of 'outrage' which concerns a great number of the Muslim community. A Jewish poet living in Egypt has spoken of the novel in the following terms:

> . . . the Prophet is the devil, the law-givers are
> sexual perverts, the Kaba and the Haj are examples
> of depravity and greed, and the Koran is only a
> collection of Satanic verses.

Now it may be the case that as a piece of criticism this is not to be taken seriously, although perhaps it is. Nissan Ezekiel is the writer responsible and I know nothing about him apart from this which was printed in *Paikaar* magazine, the journal of the Pakistani Workers Association in Britain, and first appeared in the 15th of March 1989 edition of *India News*. But what his words at least imply, are the grounds for a passionate response to the novel from any reader who happens to have strong religious convictions, and not simply those readers who happen to be Muslims either. There again, I remember from my own time as a student that 'passion' was rarely regarded as 'valid' literary criticism. Not only does that point still seem to hold good; overall it begins to appear that many critics no longer regard passion as a possibility from 'serious' readers at all, and I mean under any circumstances.

Some questions: does the fact that a novel is a novel exempt it from serious, i.e. 'valid', public discourse on the grounds that the public at large is not 'qualified'? Can a work of literature only be judged by those who are trained in making literary judgments? Can moral judgments be applied to works of art? Can someone who has trained in Moral Philosophy criticise a novel? Can someone who is

trained in Carpentry? Or is such criticism 'invalid'? What are the grounds for 'validity' in our society? Is it possible to be *socially* responsible without qualification? These questions are also to do with the problem of 'specialism', 'the cult of the expert'. At present here in Britain the ordinary public are being forced to concede the right to criticise, the right to examine, the right to judge. The entire question of freedom of speech and expression is wide open just now and to some extent *The Satanic Verses* is little more than a red herring.

Apparently "many Westerners find incomprehensible the Muslim reaction to Rushdie" and according to Jack Shamash of the erstwhile *Sunday Correspondent* (4/3/90), by way of explaining the phenomenon, "some commentators point out that Muslims come from an oral culture". This sort of myopic elitist nonsense derives from the same form of prejudice as that which assumes literature to be the property of a 'small coterie' of folk 'educated at exclusive institutions' and/or otherwise 'assimilated' parties. The one thing it cannot derive from is a reading of the text. And the 'Westerners' here referred to are committing precisely the same breach of responsibility as those members of the Muslim community who are condemned for attacking Rushdie's novel without having read it, for it is quite obvious they too have not read it. More than that, they are simply demanding the continuing 'right' of English literature to insult and verbally abuse. I am not opposed to the right to insult and verbally abuse. As a writer myself I am in favour of freedom of speech and expression and accept that such freedom *must* include such rights. I hope very much that my stories have insulted and abused, if they have not then I have been failing much more than I had hoped. I have my own prejudices; some that I know of but others I may yet be ignorant of; and there definitely do exist certain groupings that I try to attack. But that's life, it's the nature of the work.

People of various religions and various secular beliefs have been insulted, abused and outraged by the Anglo American tradition in literature probably for as long as language has been a means of artistic expression. Different religions, different castes, different classes, different cultures, different accents and different languages; generally speaking people who are 'different' have always had grounds for feeling aggrieved ('different to whom' is the obvious but rarely addressed question). But within a literary context any poem, novel, play or short story can be 'good', even 'major', when

the selfsame work is racist, class-biased or elitist. And the tricky part of this is that if as a society we do demand freedom of expression then we have to be prepared for the 'good' being defined as the 'bad'. This may be a paradox but it is no contradiction. It just means we are operating in another context, the literary good can be morally suspect.

This applies not only to mainstream Anglo American literary totems like Rudyard Kipling, T. S. Eliot, Joseph Conrad, Evelyn Waugh, Henry James and so on, but figures such as Fyodor Dostoevski, and perhaps even Hugh MacDiarmaid.

Forms of prejudice obtain in all literary traditions. The logic of this argument may lead directly to tautology in terms of language itself. No one is beyond the language s/he uses. Writers may try as hard as they can, but like everyone else they remain a part of it. This does not mean folk are stuck with the conventional values and prejudices of the culture they find themselves in through the accident of birth, it just means it is a fight to be clear of it. Racism and other forms of elitism are endemic. For the writer in particular the fight is through language, and subverting the value-system is intrinsic. But losing the fight does not preclude the possibility of literary merit — even greatness. There is no contradiction.

There is an argument on the side of 'modernism' that can minimise particular social influences on behalf of some greater 'universal' but this strikes me as valid only to a point, beyond which it degenerates into yet another elitist attack on the 'local', to use the term Tom Leonard and others would apply, and ultimately leads back to the marginalisation of indigenous cultures.

The way out of the problem is simply to be honest and to be open about it. But as things stand the problem is kept under wraps. As far as the current impasse over Salman Rushdie's novel is concerned it is high time the subject was aired properly, and the public admitted entry. Not everyone is knowledgeable on the subject of the English literary canon but anyone can spot a stereotype; maybe not all stereotypes but certainly some. And all readers make critical judgments. Even the act of 'skipping a sentence' is a judgment. It is just that literary critics should be able to give a fuller account of their own specialist subject than the average layperson; just as a moral philosopher or carpenter should, *in general*, be better equipped to give a fuller account of the workings of his or her own discipline than somebody not trained to it.

Unfortunately, like most of our other institutions, the mainstream Anglo American literary tradition is seldom available to challenge. And, whereas it rightly demands freedom of expression, where this has become insult and abuse it wants to be beyond criticism, it demands the right not to be judged — even by those who are being insulted and abused. It will not allow a wider social context. Retaliation remains inadmissible. When the 'victim' defends it is seen as attack, the grounds for outrage having been deemed 'invalid'.

If contemporary literary criticism wants to be taken seriously then it must become socially responsible. The right to reply has to exist. Whenever an 'outsider' inquires as to what constitutes the good in English literature it should never be enough to cry: Unconstitutional! About all the layperson is then allowed to say is something along the lines of "It may well be a good novel but I don't like it." Side by side with that: "If this is English literature then you can stuff it, I'm having nothing to do with it." Literature degenerates into something akin to tiddlywinks, not to be treated seriously, unworthy of any significant debate. In fact this is probably the position held by the bulk of the British people, given that the vast majority of the citizens of this country, no matter their racial origin, are the butt of its endemic, elitist prejudice "all, that is, but the tiny portion of it represented by Rushdie" and all the others who have "been educated at exclusive institutions" and thereby 'assimilated' into that self same 'small coterie'.

For those living in this country who are still able to take literature seriously I strongly recommend the stories of Sadaat Hasan Manto. Manto is, without question, a major writer — no particular literary context is necessary to make such a proposition. His short stories can be mentioned in the same breath as anyone at all:, at his best he is as strong as Isaac Babel, or Lu Hsun, or Isaac Loeb Peretz, or Anton Chekov. Although born into a Muslim middle-class household in what is now Pakistan, Manto lived for a considerable period in Bombay from where he eventually had to return 'home'. This was in 1947 and his country had split into two. It was the year of Partition (coincidentally the year Rushdie was born) and a time of unbearable upheaval and horror for hundreds of thousands of folk. Muslims were trapped in India and Hindus were trapped in Pakistan; if you were a Muslim born in 'India' it

was very tough indeed; similarly if you happened to be Hindu born in 'Pakistan'.

It was in Amritsar that the atrocity occurred in 1919. The British Army opened fire on a crowd of unarmed men, women and children who had gathered for a public meeting during the *Baisakhi* day celebrations, a religious festival. Official Government estimates of the day put the number of dead at 379 (the real figure was much higher). In common with many people in the Indian subcontinent the *Jallianwala Bagh* massacre exerted a considerable influence on Manto for the rest of his days. That and some of the horrors being perpetrated in the name of Communalism provide the background to some of his greatest work:

> On at least two occasions, once in the early 1940s
> and the second time in 1948, (he) was prosecuted
> for 'obscenity.' The guardians of public morals in
> the new Islamic state of Pakistan had found his
> story about the young girl who is first abducted by
> the Hindus and Sikhs during the partition of Punjab
> and then recovered, raped and left for dead by
> some of her new Muslim countrymen, obscene,
> anti-state and degrading.

The short story in question is as beautiful and powerful a one as you could hope to read. And it strikes me as very pertinent indeed that almost no one who is reading this article, unless able to read Urdu, will have even heard of Manto's name let alone read his work. He died in 1955 but his writings remained unpublished in English until three years ago (the above quotation comes from the Introduction by Khalid Hasan, translator of the work). At the present time just this one collection of stories is available in this country; but since it is published by Penguin Books of India it might only be available from that tiny band of what's known as 'left-wing' bookshops, which may or may not be another kind of suppression. But good hunting anyway. The one in Leicester where I managed to buy it continues to operate in spite of different attacks, some of them physical.

I mentioned earlier that everyone is aware of prejudice. None more so than folk from the Indian subcontinent. People from India,

Pakistan or Bangladesh have not found it necessary to emigrate to become victims of prejudice. This applies not only to Muslims but to Hindus, Sikhs, Parsees, Jews, various Christian sects and atheists. Prior to the appearance of *The Satanic Verses* Penguin Books in India had been advised of the possible consequences if publication went ahead, and the first official suppression occurred in the same country. Muslim people constitute a very powerful minority in India, more than 100 million. It is easy to be critical of Rajiv Gandhi's decision but without contextual knowledge of the circumstances such criticism might not only be worthless but potentially damaging. Communal politics have been a plague for some considerable time now in the subcontinent, just as similar sectarian forms have been elsewhere — Northern Ireland and the Lebanon to name but two examples. Communalism begins from

> the belief that people who follow the same religion
> have common secular interests, that is, common
> political, economic, social and cultural interests. (It
> is) the ideology of a religion-based socio-political
> identity. In other words, religion is not the 'cause' of
> communalism, even though communal cleavage is
> based by the communalist on differences in religion
> — this difference is then used to mask or disguise
> the social needs, aspirations, conflicts, arising in
> non-religious fields. (*India's Struggle for Independence*
> by Bipan Chandra and others, Penguin books, India
> 1988).

Like other forms of sectarianism, communalism distorts reality, it advances division and encourages prejudice. But sectarianism and fundamentalism are concepts that cut across all religious boundaries. Part of the worry over the present controversy is that until the point where criticism is possible nothing at all will be possible. And this plays right into the hands of those who use such politics for their own self-interest whether they live in India or Pakistan or Sudan or Iraq or U.S.A. or Israel or here in Great Britain. As far as Iran itself is concerned, Maryam, a spokesperson for the CARI group (the Campaign Against Repression in Iran) reminds us that "thousands of Iranians have been executed under

(their) blasphemy laws" and "the main brunt of the attack of Islamic fundamentalists is directed against progressive forces within their own communities. Women, workers, the national minorities were amongst the first victims of the fundamentalist onslaught (while) in Britain, within the Muslim communities, women have been the first victims . . . ".

But at this point perhaps the last word should be left to the Iranian journalist and poet Manouchehr Mahjoobi, made shortly before he died in London last September:

> . . . the history of my country is a long history of struggle between intellectuals and zealots. And this struggle is continuing today despite sacrificing thousands of lives.

> Before Ayatollah Khomeini's *fatwa*, against Salman Rushdie, nobody in the west could imagine that a mullah in Iran was able to sentence a Western writer to death.

> We, the Iranian writers, have been crying to the world for years that mullahs in Iran indeed kill writers. No one listened to us. Now that a British writer has been subjected to Khomeini's *fatwa*, the world has learnt the dimensions of this catastrophe.

17/3/90
(published in *Glasgow Herald*, and since revised)

Art and Subsidy,
and the Continuing Politics of Culture City

Versions of this essay have appeared in The Reckoning *(Clydeside Press, Glasgow),* Making Sense *(Repsol Ltd., Dublin) and as the introduction to my collection* Hardie and Baird; and Other Plays *(Secker & Warburg, London)*

Arguments against public funding of the arts in this society might well be logical but they aren't rational; and decisions to cut or withdraw subsidy are always political. Greed is the ultimate motivation. This is illustrated by the national government which pretends to various philosophic absurdities while doling out massive sums of public money to private enterprise. It applies also to local government; and in Scotland, as with much of England and Wales, local government where it matters is not Tory, it is Labour. But what is happening in the arts is happening in every field where public funding is paramount, especially in those very rare instances where actual 'profit' *remains* with the public. In our society profit is supposed to be private; the ordinary public is left with the loss: thus questions to do with art and subsidy move rapidly into other areas, and 'profit' can be defined in any number of ways, e.g. good health, a pleasant environment, efficient transport, a just legal system, a high standard of general education, and so on.

An integral part of the 'City of Culture' concept is crucial to anybody with an interest in art; I'm talking generally, not just about painting but literature, theatre, music: anything. It's the assumption that a partnership already exists between the arts and big business and that such a partnership is 'healthy'. It suggests a heady mixture of high principles coupled with 'sound' business sense. Business sense equates with 'common sense'. It is implicit that left to their own devices those

27

already engaged in the field are not quite up to the more mundane practicalities. Art doesn't just need the money; it needs the thinking behind the money. Folk already engaged in the field might hold lofty ideas to do with morality, aesthetics, the human condition, and so on and so forth, but when it comes to making a thing 'work' they need help from more down-to-earth sort of chaps. Art is all very well but out there in the 'real' world it's a fight for survival.

The battle has been on for years, people struggling for private funding, trying to tempt open the sponsor's purse; competing with each other, some winning, some losing. The evaluative criteria employed by those in control of this purse are not known to myself. Predicting their motivation is more straightforward. But it seems safe to suggest that the art most likely 'to win the money' will conform to certain precepts deriving from these criteria and will be decorative rather than challenging. The work of an unknown novelist, sculptor, poet, painter, playwright or whatever begins with a handicap, as does anything too radical or experimental or in some other sense 'geared to a minority audience'. Like any successful product, a work of art should be acceptable to as wide-ranging a market as possible. 'Market' here means media-response as much as potential audience. If a subsidised theatre company or gallery or publishing house is doing its job properly — that is, acting in line with current 'market-place' philosophy — then 'sponsor-appeal' exercises an influence on how it *commissions* plays, events, novels, exhibitions and so on. In the case of theatre, for example, a company no longer approaches a variety of local businessfolk for various bits and pieces connected with the production itself; an initial cash injection is nowadays essential. Therefore the criteria of the market-place comes to form part of the company's *own* criteria for judging the worth of new work. Not the merit, the worth. Its value is determined by its potential 'sale' to the private sector. A 'difficult' play — or novel, or painting — is no longer a challenging piece of original work, it is one deemed worthwhile but thought unlikely to find major funding from private sponsors.

When a theatre company wants to produce a 'difficult' play but cannot entice a private funding body to help subsidise the enterprise it is left with a limited set of options. Offering a 'workshop' production is one. This immediately breaks through the public subsidy 'barrier'. Any publicly funded arts body must abide by certain agreements, one of which guarantees the artist a minimum fee for her or his work. On a

'workshop' production the playwright has the 'freedom to choose' either a token fee or else no fee at all. It further solves the 'union problem': the company need not pay its members to the minimum Equity rate. In fact, they need pay no wages at all, only expenses. A 'workshop' production offers not the ultimate exercise in cost-cutting, which is voluntary liquidation, but it does mean great savings all the same: no rehearsals, no set, no sound, no lighting, no nothing. The actors have the 'freedom to choose' their own clothes or no clothes at all, they stand on the stage with manuscripts in hand, doing a sort of performance reading. Nobody has the remotest sense of being involved in an actual play. And for the audience, who frequently have to pay at the door for the privilege, the experience is not quite as good as being present in a recording studio when a radio dramatisation is taking place. 'Workshop' is a way of paying lip service to original work and new writing. Few companies like doing it.

And one which wants to maintain full production interest in a 'difficult' play can feel entitled to wonder if an element of 'script-liberation' would broaden its sponsor-appeal, i.e., can the manuscript be adjusted slightly to make it that bit less off-putting to the folk holding the purse. So as well as controlling initial decisions on the production of new work the private sector is nowadays exerting influence on 'script-development'.

What it comes down to is imposition, the imposition of external value on criteria that should be the province of art. The folk with the money hold the power. This is true to the point of banality for those writers, directors, actors and others engaged in dramatic artforms within film and television; and a short answer to the depressing state of affairs in either medium, where to describe current output as second-rate is generally taken as a compliment. The artists there have long since conceded control.

But the one obvious, though seldom acknowledged, correlate of the shift from public into private sector arts subsidy is the increase in suppression and censorship. It's hard to imagine a dramatisation of the offshore oil workers' fight for improved safety conditions 'winning' sponsorship from B.P., or any other major oil corporation; as hard as it is to imagine U.S. corporate funding for a dramatic realization of its entrepreneurial activity in Central America or the Middle East, or in Turkish Kurdistan.

And oppression leads to repression; the situation where writers and artists stop creating their own work. They no longer see what they do as an end in itself; they too adopt the criteria of the 'market-place'; they begin producing what they think the customer wants. The customer is no longer even the audience, nor is it the commissioning agent of the theatre company or gallery, or publisher; the customer has become the potential sponsor, the person holding the purse strings on behalf of private business interests. What the artist is now producing has ceased to be art; it has become something else, perhaps a form of decoration, or worse, just another sell-out.

People engaged in creating art continually make decisions on whether or not they continue working at what they do. Even where it becomes possible to survive economically at it. This is because the vast bulk of the work on offer is geared to the needs of private sector money. Such work is not only meaningless but often in direct conflict with the artists' own motivation, I mean political, moral, aesthetic, the lot. Some hold out by entering extended periods of 'rest'; others try for a compromise; they do the hack stuff and trust the money earned 'buys time' for more meaningful work in the future. But anyone who relies on the private sector for the economic means to create art, and continues to believe they are in control of the situation, is very naive indeed. But some 'artists' are naive, they prefer it that way.

Within the higher income bracket in this country many people express concern at the hardship endured by artists. They assume the group is part of their own and therefore empathise with them. 'That could be me', they think. Others from the same income bracket are not depressed, they take the more aggressively romantic line and accept the necessity of suffering for art's sake. They do not for one minute think 'that could be them' but believe in the freedom to starve. Members of either faction assume artists receive their just reward at some indefinable point in the future, in the form of cash or glory, perhaps posthumously. If some artists never succeed in 'winning a reward' from society at all then they couldn't have been worth rewarding in the first place. Perhaps the work they produced wasn't very good. Perhaps it was 'wrong'. Maybe it just wasn't Art at all: for within these circles of conventional left- as well as right-wing thought the myth that art with a capital 'a' is both product and property of society's upper orders is taken for granted. They're always surprised by the idea of 'working class'

people reading a book or listening to a piece of classical music. The possibility had never occurred to them.

And there's another line springs from the same mentality, the opposite side of the coin, often thought to derive from a 'class position'. This so-called socialist position (usually Stalinist but not always) accepts the elitist myth wholeheartedly, and therefore denounces Art for that very reason, it is elitist. And all of those engaged in its creation are self-indulgent time-wasters, dilettanti. Those who take this line will make a case for Agit Prop, or what they term Social Realism; or revues where every song, joke or dance is followed by some polemic or other, working on the same principle as the Band of Hope or the Salvation Army — they give you a biscuit and a cup of milk but insist you sing a hymn or else watch a slideshow about missionaries and the black babies in exchange. It never crosses the mind of the vanguard that people living in Castlemilk, Drumchapel, Easterhouse, Craigmillar or Muirhouse, or any other housing scheme in Britain, might prefer a play by Chekov or a painting by Cezanne or a piece of music by Puccini to whatever else is being forced down their throat. A case will be advanced by those and others for what is euphemistically termed 'community art', i.e. art of the 'workshop' variety; apart from administrative and basic material costs it is produced for next to nothing, and helps keep idle hands at work — thus groups of teenagers trying to survive on no-money per week are given a tin of dulux and told to paint their face, or maybe pensioners are asked to write their memoirs which are eventually photocopied and stapled together, then dumped into the shredder when the next administration takes over.

In 1990 in Glasgow conventional myths to do with art and culture and public funding and private funding were given full rein. The concept itself, 'City of Culture', was always hazy, extremely dubious indeed. It had more to with etiquette than anything else. But if boldness is one essential ingredient of entrepreneurial activity then those who decided to 'go for it' are Labour champions of the New Realism. What becomes clearer by the day is that both the adoption and application of the concept derived from another heady mixture: intellectual poverty, moral bankruptcy and political cowardice.

It might appear contradictory to describe such a bold and grandiose scheme as cowardice. We are talking about an outlay of some £50 millions after all, given in the name of art and culture, to entice private investment to the city and its environs. But it was an act of cowardice.

31

At national level Scotland is ruled by a minority party, the Tories. The holders of municipal and regional office are elected by the people to offer some sort of local challenge to the present government. Instead of offering such a challenge our politicians have capitulated in a quite shameful manner. Instead of attacking the national government they attack the people. They have implemented policies of a sort no Whitehall Tory administration would dare attempt north of the border. At a recent anti-poll tax demonstration the Labour Leaders accused, actually accused, the police of adopting a 'softly-softly' approach, they called for the forces of law and order to wield the 'expertise' they deployed during the miners' strike.

Over the coming years the cost of this one P.R. exercise will have repercussions for the ordinary cultural life of the city. The money had to come from somewhere. Major cuts have already taken place in these areas precisely concerned with art and culture. The public funding of libraries, art galleries and museums; swimming baths, public parks and public halls; all are being cut drastically, and the people fighting the poll-tax are of course taking the blame. Prime assets not to mention services to the community are being closed down and sold off altogether, to private developers, to big business. What has been presented as a celebration of art in all its diversity is there to behold, a quite ruthless assault on the cultural life of the city. Right at this moment (October 1991) we now have what is technically an epidemic of dysentery, a so-called 'Third World' disease, a direct effect of the council's inability to deal with sewage and garbage disposal. Fortunately for the politicians the mainstream media are somehow unaware of the news.

Beyond the future servicing of visitors to 'our' new cultural complexes, there will be some sort of 'reward' for the people of Glasgow. No one can spend that amount of money and fail to buy something. But authentic benefit for the many rather than the few seems destined to concern art itself. And art is the product of artists. And so-called 'community art' is also the product of artists, that is, if so-called 'community art' is anything other than a necessary part of that foregoing elitist myth.

Art is not the product of 'the cultural workforce', a term I first discovered in the summer of 1990 when myself and other writers were severely censored by a top arts administrator for bringing the city into disrepute. The term of course refers to those who administer public

funding and/or private sponsorship for 'arts' initiatives', and gives rise to the peculiar notion that without such a workforce culture would not exist *properly*, that without such a team of administrative experts who operate on behalf of that heady mixture of public and private enterprise, *art* itself would not exist, not 'out there', in the real world, where life is a war and poor old Art, with all its high principles and quaint ideals, would simply wither away and vanish altogether.

But in that so-called 'real' world the only real terms are cash terms. And the only real criteria are the criteria that set the conditions for real cash profit.

It is a measure of the repressed nature of this country that people who would align themselves either on the left or on the side of the artists, still defend the 'Year of Culture' let alone private sponsorship. Within the terms of their own argument they must defend glaring blunders like the cultural flagship *Glasgow's Glasgow* temporary exhibition which lost somewhere in the region of £10 million of public money, a quite astonishing sum. They find it possible to accept that misconceived farce as an 'aberration', a phenomenon, somehow managing to ignore what was at that time public knowledge, that Ms. Elspeth King and Mr. Michael Donnelly had predicted the outcome more than a year before the event opened. They defend inefficiency, humbug, hypocrisy, diverse victimisation and misrepresentation, not to mention financial dealings verging on willful negligence if not fraud. They cannot bring themselves to acknowledge that the £50 million spent is 95 percent money down the drain, that they have been used as willing dupes. So they continue in some kind of half-embarassed, patriotic high-dive towards a mythical general good, which if it doesn't exist has at least found a name, 'Culture'.

If there is an air of familiarity about the logic of their argument, recollect Lord Denning's suggestion that it was for the common good that innocent people be incarcerated for life — better a miscarriage of justice than that the fact itself should be admitted: nothing is more damaging to the Law than when it is not only wrong but shown to be wrong, not only wrong but confesses itself wrong.

The architects of the concept 'City of Culture', as it applied in Glasgow, were politicians and entrepreneurs. The politicians represent themselves as the public and the entrepreneurs represent themselves period. Cash investment in the city and environs was the primary motivation, as the politicians confirmed publicly. There is nothing

wrong in that as far as their view of the 'real' world is concerned, it is perfectly consistent. And also quite consistent to assume, given the criteria, that profit in real cash terms from the investment will remain private, that the costs and any ultimate loss will once again belong to the public.

It is important at this point to distinguish between politicians and those they are elected to represent.

Folk who defend or justify the expense in terms of art and the cultural benefits to the public have no valid argument at all. If they manage to rid themselves of the criteria of the so-called 'real world' then they are left with millions of pounds of public money to spend on the arts and culture in this world. This world is different from that other world. In that other world there is only one set of criteria, designed to set the conditions for personal monetary gain: in this world — the one where art and culture exist — there are a variety of sets of criteria; they include the one mentioned, but also others such as the moral, the aesthetic, the humanitarian and so on.

No one has to be opposed to art 'dirtying its fingers in the market-place'. Nor does anyone have to be in favour of it. The question is irrelevant. What is at issue is value; the criteria by which we determine merit. And in the world of the 'European Cities of Culture' a work of art is judged by the financial expediency of big business.

The people of Glasgow were presented with a yet another fait accompli, by a partnership supposedly there to represent public and private interests. But in reality the interests were always private. The only surprising thing about the fact is that people were surprised by it. Meaningful debate on the subject never took place, it wasn't allowed. When Michael Donnelly attempted to express the reality of what had taken place he was sacked. This too should not be surprising. Secrecy, censorship and suppression are essential ingredients of the 'real world' of private profit and public loss. Nowadays this is achieved by open decree. Taking its lead from the Tory national government, local officials of Labour-controlled District Councils up and down the country are suppressing and censoring voices of dissent, content to do so publicly if forced into it. When that fails they try to punish those who dare speak out.

Contemporary government, municipal, regional and national, is rooted firmly in the structure of U.S. corporate business management, the process has gone on at least since the mid-1970s. Our elected

representatives and custodians have been transformed into chief executives. At the highest level their power is centralised to the point of autonomy. They are no longer accountable to anyone. Our artistic and cultural assets, in common with our economic resources, have become their property, not to keep for themselves but to dispose of, and to dispose of entirely, as they see fit, to whomsoever they see fit. And anyone who gets in the way is trampled upon, by whatever means are necessary, aided and abetted by our compliant media.

But it's easier to focus attention on a victim rather than seek out the cause of the violation. Nowadays we make victims of people and then punish them for being victims, transforming them into objects of ridicule or even criminals. Those who attempt to defend the victims are themselves victimised, sometimes they too are 'criminalised'.

The problems faced by those who attempt to work for the mainstream media while retaining a degree of integrity is much too large an issue to discuss fully here. But it makes no difference how good a journalist is if the work cannot be done in the way it should be done, if the values of the journalist are not only an irrelevance but a positive hindrance in the face of those who own or control the purse strings. Unfortunately many of those engaged in the field are so far repressed they have lost sight of the reality. When confronted by folk who persist in criticising certain aspects of society they cannot get beyond the criteria within which they themselves are forced to operate and thus, intentionally or otherwise, are forced to seek ulterior motive or personal interest where none exist.

But whether we attack victims or defend victims, in a repressed society, we do so by ignoring the context. If we go through the list of oppressed groups and communities of people in this country we see that our institutions are geared to punish them, and are being refined constantly to that purpose. White people can attack black people or defend black people and somehow manage to ignore the actual institutions of state which are, quite simply, racist; they are *designed* to victimise black people. And whenever somebody excavates a hole in some oppressive legislation or other a government expert is sitting about waiting to pour in a ton of concrete. There are local monitoring groups in this country that exist solely to aid and support victims of racist violation, including

murder. They themselves are punished, they are criminalised. Their public subsidy gets withdrawn; they are harassed and intimidated by the forces of that Law and Order so beloved by the likes of Lord Denning, or Neil Kinnock, or John Major. Their aims and objectives are distorted and misrepresented, again with the help of the mainstream media.

And as in the last example waged people can attack or defend those on income support, while ignoring the state institutions now designed to punish them further. And we can then find ways of attacking those who go to their aid, whether individuals or even official organisations connected to the social services. Anyone who signally highlights the plight of society's victims is guilty, in the eyes of those who control society; they are guilty of implying a cause of the violation.

The most straightforward method of punishment is the slow withdrawal of public funding. The cost-cutting exercises then begin. The service provided to the victims is eroded until eventually the entire edifice collapses. As with subsidised art this leads to the fight for private funding which in this area may be classified as 'charity'. If we are talking about a service for the people then normally it just becomes absent, it ceases to exist, like the drinking-water we used to think belonged to us as of right.

A few older, liberal-minded folk still maintain that An Age of Liberalism existed from a point in the mid-1960s until a point in the early 1970s. I'm speaking of the arts in particular although some might want to generalise. In either case it may or may not be true. It probably is true for those who assume that the British Broadcasting Corporation was once an authentic instrument for freedom. But in present day Scotland, as elsewhere in Britain and most of the so-called 'free world', it isn't art and big business that are close allies, it's art and subversion; the notion that creative endeavour has a right to public — let alone private — subsidy is not a paradox, it is a straightforward contradiction. It's much more consistent that people engaged in the field as an end in itself should be attacked, in one way or another, for this is a time of punishment, out there in the real world.

Some Recent Attacks on the Rights of the People

The Citizens Rights Office had its funding withdrawn in the summer of 1991. One of the waged employees* was the specialist on race and immigration issues, not only in Lothian Region but throughout Scotland. His actual presence gave the lie to the myth that there is no racism in this country. By doing away with the position held by him it is suggested there was no need for it in the first place, either that or there is no need for it now. It's an interesting logic used by authority everywhere. If you get rid of the means by which people make their grievances known officially, and to that extent publicly, then officially, and publicly, people don't have any grievances.

Lothian Regional Council is a Labour council. Some will view this as an 'irony' since they see this party as 'socialist'. Clearly it is not socialist, although some of those who made the decision to withdraw funding from the Citizens Rights Office (as well as other community-based projects and self-help groups in the area) do describe themselves as such. Elsewhere in the country a great many others in control of local government do likewise; meanwhile they bend over backwards in their dealings with private enterprise. Generally, the deals are conducted in private, by two or three people in an office. The decisions are then presented at an appropriate committee for the nod or wink of approval. This process is referred to as 'democracy'.

Led by Chairperson Paul Nolan the 25 Labour Councillors in favour of closure maintained that the work done at the Citizens Rights Office would be carried out just as effectively by other agencies, in particular via the proposed 'One-Stop-Centre'. This is,

* Tarlocan Gata-Aura

of course, absurd. As far as the subject of race and immigration is concerned their conclusion derived from ignorance: if not then what they maintained was false, not only false but known to be false at the time they made their decision, in other words they were telling lies.

On the subject of racism the Citizens Advice Office was a constant reminder of the contradictions within our society. If our institutions were not in *themselves racist* then it is possible the specialist function performed by the worker involved would never have existed in the first place. In that case racial abuses might well have been dealt with by other agencies. But this has never been the case. It so happens that our immigration laws are racist, that our legal and penal systems are racist, that our educational system and various other social structures are also racist. Those who have to suffer because of the reality have been telling us for years. Those who go to help the victims have also been telling us. Anyone with any knowledge of this field is aware of the reality. None more than the specialist whose position has now been terminated by Lothian Regional Council. By its very nature the role he occupied was oppositional. There was no alternative. If the job was to have been done properly it presented a challenge to the power base, it questioned the structures of our society: for every victim he assisted a shadow was cast on the system.

Obviously some authorities regard this sort of thing as a threat, not because it highlights the existence of racism in Scotland, nor even that it highlights the racism endemic in our institutions; it is a threat because any challenge to authority is a challenge to the folk who happen to be in authority. In a healthy democracy no structure is beyond public scrutiny. If our society was in good moral order such challenges would not be perceived as a threat, they would be welcomed. But our society is not in good moral order, which is why social and racial injustice prevail to the extent they do, and why structures like the Health and Social Services are now in the process of grinding to a halt altogether. But nothing is more threatening to the authorities than an investigation of the system itself; it implies a structural fault. Better that those on the lower end of the social scale are punished and victimised than that our democracy is revealed for what it is.

When private business interests control the welfare of society as at the present time — it widens the rift between communities and individuals, fracturing and destabilising solidarity. It leads to

38

every deprivation imaginable, the end result of a system whose central purpose is to secure the wealth of the wealthy. People compete with each other in the most ridiculous manner. The process dictates that worker fights worker, employed fights unemployed, catholic fights protestant, christian fights muslim, white fights black, and so on and so forth. In the struggle for resources you have a situation within the Social Services where separate agencies now vie with one another to 'win' adequate funding. They must justify their 'privilege' to assist the poor.

People die as a direct effect of state policies which could not be implemented but for the complicity of all the parliamentary parties. In a genuine democracy a vast number of politicians would never get anywhere near public office. Instead they are allowed to develop new ways of wreaking havoc with people's lives, more or less unchecked by their 'bitter foes' on the opposition benches.

The truth of the matter is of course that the ex-workers at the Citizens' Rights Office, paid and unpaid, and the volunteers at the Unemployed Workers Centre, plus all the other community-based support-groups who have now had their funding withdrawn or remain under threat of it, have been doing the very job the politicians of the opposition parties were elected to do. That's what they were elected to do, these so-called socialist councillors and M.P.'s in Lothian and throughout the country: they were elected by the people to fight on their behalf against the Tory assault. Instead of attacking the exploiters they collude in the Tory assault. They do this in different ways; the victimisation of support-groups like those mentioned above is just one example.

Across in Labour-controlled Strathclyde Region as elsewhere they also steal money from students and favour warrant-sales on the homes of working class people, then they condemn the police for *not* adopting a more heavy-handed approach on the folk who go to defend the families under warrant-sale*; and they try to dock the wages of people fighting the poll tax who work in the Social Work Department; the very people they employ to assist the victims of Tory policy. But these forms of victimisation are an essential aspect of national government strategy and could not be implemented without the connivance of the Labour Party-controlled local authorities.

*like Charles Gray, leader of Strathclyde Regional Council.

At local government level our elected members pay lip-service to politics but essentially none of them has any. Open debate is avoided at all costs. When obliged to confront it the politicians in question appear simply foolish, fodder for the opposition. On the other hand their one basic 'quality' — the ability to manipulate — is apparent to the world. Beyond their own backyard they know little aside from what they read in the newspapers or see on television and appear equally ignorant of the Labour Movement they were elected to represent. Yet from within the conventional wisdom of domestic 'realpolitik' they regard this ignorance as a badge, they're proud of being hustlers, of 'making things happen'. And they remain in power, gathering about them teams of 'professionals', management specialists.

These days the very top managers can go just about anywhere and work in any field. From the car industry they take control of the steel industry, or the coal industry, or the health industry, or the arts industry, or the education industry, or the museums and galleries industry, or the public utilities industry. A personal interest in the subject is fair enough but not in the actual place the work is to take place which is not only irrelevant but downright dangerous. It could prejudice 'tough' decisions that have to be made in the interest of 'strong' and 'efficient' management. The best people to take control at the highest level are those with no localised interest at all, preferably folk from outwith the community or culture directly affected. This is why the top posts always go to outsiders. The logic is the same as that used by governments who wish to set the army on its own people.

Thus Labour-controlled local authorities appoint people ignorant of a community's art to take charge of its cultural well-being. Those who care nothing for local conservation are given control of the Parks Department. Folk with neither knowledge nor understanding of the value of a community's social history gain control of its museums and galleries. In all spheres of public life, and throughout Britain, the people who don't care are 'winning' the top jobs. They are being patted on the back by our elected representatives who take a pride in their 'unbiased and objective' motives, their capacity to perform the requisite 'cost-cutting exercises' with supreme efficiency, or ruthless expediency, depending on the PR needs of the moment.

And where out-and-out calamities occur through the inability of the 'professionals' to recognise the needs and potential of a community no one remarks on it, it's seen as an aberration, a phenomenon. Whatever the system is and however it currently operates, its value is there to behold, in the shape of those spewed into high office by the party machine, by those in turn appointed to the highest managerial positions.

Within the country's local authorities morale among the workforce has never been at a lower ebb. Those who should be promoted either fail the selection process or are too scunnered to apply. Absenteeism and sickness; voluntary redundancies, early retirement: people just want out.

The outstanding Chief Librarian Scotland has seen for many years, Joseph Hendry, eventually conceded the struggle and moved to England. He had applied for the top post in Glasgow. But on a split decision the casting vote was taken by Chairperson Jean McFadden who chaired the appropriate committee. She thought him too radical and his application was rejected. Now that her 'socialist' colleagues in Renfrew District have him safely out the way how long will it be before the restrictive and reactionary practises are introduced, the ones he spent 15 years trying to resist or eradicate in an attempt to honour the people of Renfrew's right to a decent library service? Elspeth King and Michael Donnelly have been hounded out of the People's Palace museum in Glasgow where they were censored, suppressed and generally victimised by officialdom, both political and permanent.

As with Tarlochan Gata-Aura the three mentioned would describe their politics as socialist in one form or another. Some people may find that ironic. But it's logical that the main punishment is reserved for those whose political sympathies are based in deed rather than word. It's happening throughout the country. Those who attack the rights of the British public are supported; the 'radicals' who defend them are attacked.

The vast majority of Scotland's elected representatives are moral and political cowards. They pretend to represent the public interest but in reality they represent the selfsame interests as their Tory colleagues. The system is designed to weed the exceptions out at an early stage. If they contrive to stay and fight real power is taken from them. There is no support from above. The exact opposite: those who come to the

aid of the people instead of the party are the enemy. This was given sharp emphasis by a high-ranking member of the Lothian Labour group who was interviewed by the press on the day their Management Committee convened to supposedly 'listen' to the various community-based advice-centres attempt to justify their right to enjoy the privilege of assisting the public. During the debacle a demonstration took place on the street below. Some 200-to-300 people were involved, including disabled people, pensioners and quite a few kids of pre-school age. At one point in the interview the Labour official confided to the journalist that the real enemies were not the politicians of the opposition parties but "these people out there on the street".

The truth is of course that for "these people out there on the street", the real enemies are those within the political power structure, no matter their political hue. All the public 'assets' now under threat (the ones not yet closed down or sold off) will not be saved by political representation. Those who wield the power are those responsible for the decisions in the first place. Making representation to Nolan, Milligan, Begg, or Lally, McFadden or Gray is as pointless an exercise as negotiating with George Bush, John Major or Neil Kinnock.

Power politics is just a business and like any other business profit and loss is defined in terms of cash. Official 'politics' is a game, conducted in a series of nods, winks and hidden agendas.

Racial justice and social justice: in a genuine democracy these forms of profit would be uppermost not only in the words of the politicians but in their actions. But they concern themselves with more pressing matters. Leaving corruption and personal greed aside this means security of tenure, keeping the nose clean at party headquarters; posing as 'statesmen' or some such nonsense, trying to prove they are responsible and reliable. Responsible to established authority; reliable for the purpose of government. These are the priorities. The state is master. If this was not the case they wouldn't have reached high office.

Big business and those who act on its behalf get rewarded; the ordinary public and those who act on their behalf get punished. Factories close and industries are lost; culture is eroded, communities destroyed. The right to proper living conditions, a proper health service, adequate safety regulations at the workplace: all of these are

lost, as are the rights to a proper transport system, pre-school provision, sporting and recreational facilities; and so on and so forth. The Tory Party defines such things as 'privileges', articles to be acquired and sold. But they are not 'privileges', they are rights. During the past dozen years the national government has been transforming the few rights held by the public back into privileges. Marking the 200th anniversary of the publication of *The Rights of Man* they have achieved this transformation with the collusion of their 'bitter enemies', the Labour Party, more aptly defined as Her Majesty's Most Loyal Opposition.

And it is of crucial importance to here recognise the rights referred to are not 'principles' (let alone 'privileges'), but aspects of actual existence. Since time immemorial people have fought and died for them. They have been killed for them. They still are, not only abroad but in this country, on picket-lines and demonstrations, or simply out walking, like Ahmed Shehk who was murdered in Edinburgh less than two years ago, half a mile from where the Parliament Square 'socialists' decided to dispense with their race and immigration specialist. Nothing was ever given freely by the ruling class. Not in this country, not in any country. When left with no alternative they concede. If given the chance what they concede they retrieve, they fight tooth and nail, as they have been doing since the mid-1970s. If the Labour Movement was ever about anything then it's the struggle for human rights. And outside of the power structure this is what people mean when they speak about 'politics'.

Big business and those who represent it now manage this country as never before in recent years. Overtly this happens by means of the political and legal systems; by the forces of law and order, the police and the penal system, the military; by state immigration controls, the DSS, the education system and so on. These institutions and structures are designed to control the vast majority of people who constitute society, the public. It is the public who represent the central threat to those in authority and are perceived by them as the 'real enemy'. Covert methods are also in operation. Information is controlled and news is controlled. Censorship and suppression are commonplace. What the government and mainstream media admitted was happening during the Gulf War is no phenomenon. This form of control is *always* in operation.

One hallmark of an oppressed society is the lack of public meeting places. In many countries in the world the state considers the church 'dangerous'. This was and still is the case in parts of Eastern Europe; and in Central and South America, and elsewhere in the so-called Third World. But in these countries you also find that the public have no other places available. It isn't so much that religion is a threat: the threat comes from people gathering together. Talk maybe cheap but dialogue is dangerous. It can lead to action. This is why in times of domestic crisis the state will not allow groups of folk to hang about on street corners; 'mobs' of more than three people standing talking on the pavement are moved on by the police, otherwise they get done for 'loitering' — with intent to start a revolution.

The authorities prefer a situation where the only meeting place is the pub. By the time you've talked your way through the problem you're too drunk to do anything about it.

In 1990, at the height of their attack on culture, Pat Lally and the Glasgow 'socialists' tried to sell off one third of Glasgow Green to private developers, the very land where people have gathered for generations, as of right, to air and address their political grievances. That's the sinister side of it, if we need reminding, the Green is not only a prime site for the cash profit brigade it is also dangerous, it represents a political threat to local security. And similarly the Citizens Rights Office, the Edinburgh Unemployed Workers' Centre, Clydeside Action on Asbestos, and all the rest of the community-based advice-centres; they're not just places people go, or have gone, to for help, they're places people meet. And when people meet they talk, they communicate.

The national government have set the conditions to suppress such 'dangerous' places, through fiscal control and other means. Our Labour leaders have sought to transform this Tory possible into the local actual. Their arguments are Tory arguments, based on exigency, the needs of the so-called 'real' world but in keeping with the debasement of party political language when these politicians speak of the 'real world' they refer to a game.

Of course beyond the game is a world where forces govern outwith the control of the professional politicians. If you want to get some inkling of how these forces operate just to turn to the business section in the quality *Sundays*, or get a copy of the *Financial Times*. And

beyond there are the permanent troops, those who are always in power, no matter who's at Number 10, no matter the name of the opposition party. Some politicians acknowledge this privately; few do so in public, even when they're victims of it, like in two of the better known cases, Harold Wilson and Tony Benn, who prefer to remain silent about the treatment meted out to them by permanent authority, those in charge of state-controlled agencies.

The message coming in these days is clearer than it's ever been, right across the board, not just from the mainstream but the fringe left: genuine social change is not possible. All we have left is compromise and negotiation. Whatever the fight was in the past it is rearguard nowadays. Cling onto what you have, in the face of irresistible forces. Only the 'loonies' think otherwise, dewy-eyed idealists and sentimental fools, people who live in a dream world.

Fortunately, instead of being the only group with a 'hold' on reality these 'realists' are among those most blind to it. In this as in other countries the shift is to direct action, mobilisation — known in the game as 'civil disobedience' — giving the lie to the "change-is-not-possible" message. Where have the 'realists' been during the past dozen years' riots, strikes, protests and demonstrations? Or do such 'phenomena' not count in the 'material' world? Some of them were out on the street when it was given the okay by party leaders. You wonder what they were seeing or hearing? Maybe they accept the explanation put forward by their 'bitter foes' on the right, the existence of that highly mobile yet forever anonymous cadre of 'professional agitators' who travel the world spreading pernicious lies among the docile masses.

The very fact that the state employs its forces of law and order so consistently to check direct action by the public gives the lie to the notion that radical change is not possible. If it was not possible the authorities would scarcely respond with such consistent ruthlessness. Radical change is always possible. Society can be transformed. This is not the lesson of the 1990s nor is it the lesson of the late 1960s, it's standard information that's been available to humankind for the past couple of millennium.

(April 1991)

45

Harry McShane's Centenary

a talk written for Harry McShane's Centenary, an event organised by the S.W.P. on June 28th 1991

I never met Harry McShane and don't know a great deal about him. I do know through friends that he was a great man for exploring 'ideas' which in technical terms can be described as 'philosophy'. He was what you call 'self-taught'. That kind of education happens in the workplace, or the street corner; your kitchen or somebody else's kitchen, maybe a cafe or the early stages when you're at the pub — I'm stressing the early stages. You learn through dialogue, by talking and listening, by debate; by working your way through ideas, arguing them out with friends and comrades. With a bit of luck somebody points you towards a book and you start following that through. The very last thing you need is a closed mind, you must be open, receptive.

Before you start to fight you've got to have some idea of why you're fighting. Otherwise it's meaningless. You've got to try and see things. You've got to recognise there's a problem. You've got to get to know why the problem exists. When you do that you're being critical, you're being analytic. You know not to take things at face-value, just because somebody in authority tells you it's true. When Pat Lally tells the media he represents the Glasgow public and that's why him and the gang are entitled to keep on making decisions that are ultimately going to end in a quite grievous future, we know intuitively that he's telling lies. Don't think I'm exaggerating about the grievous future; Lally and the gang've got the sort of control that the average M.P. only dreams about; local politicians don't have to cope with anything like the permanent structures of state the M.P.'s have to.

Which is one reason why the state is never too upset when the left concentrate their attention on so-called national issues rather than local ones; the more abstract the better as far as they're concerned. As I say, when Lally or any of our so-called "elected representatives" make that kind of stupid statement we know intuitively they're telling lies. The difficult bit is sorting out where exactly they're doing it. After all, the way our society operates — its basic assumptions — there is some sort of truth in what they say. So how do you get to the bottom of it. Well, for a start you examine what they say in light of what they do. But sooner or later you'll have to sort out the basics, the starting point, you wind up having to work out what they mean by words like 'democracy', what they mean by 'representation'. All of that.

I've been involved with the group called Workers' City for more than a year now. Many of you will have heard of it and hold opinions about it, not all complimentary. That's fair enough. The central factor I think binds those involved is the wish to expose political corruption, particularly on the mainstream left, where most of the hypocrisy and double-dealing exists here in Glasgow.

What this entails is gathering information and trying to get it made public. That's what keeps me involved anyway. I have to stress that it's not a party, it's a small campaigning group with many internal problems, sometimes it operates as a support group. We lend support to the publication of *The Keelie*, four A4 sides of an A3 sheet, roughly once every four-to-six weeks, and we've initiated some campaigns, the most widely known last year was the one supporting Elspeth King, bringing attention to her and Michael Donnelly's own fight for The People's Palace, not for their careers, but to safeguard the place itself, along with its tremendous collection of socio-historical relics, which they rightly regard as the property of the Glasgow people, to be held in trust for future generations.

But Elspeth was demoted (and has since left Glasgow) and they sacked Michael Donnelly. Therefore the officials, led by Julian Spalding and Mark O'Neil, are now dispersing much of the collection. So that campaign for the time being must be counted as a defeat. The other one that received a lot of attention was the struggle to save Glasgow Green from the private developers. We won that one, but these victories are never final. The authorities will try again sooner or later. Perhaps in the summer of 1992.

It's been interesting for myself to see the amount of hostility such a small group arouses, and of course the hostility that interests me the most is the kind that comes from the left. If anybody wants to ask questions on any aspect of Workers' City later on then they're welcome. There's a couple of others from the group here in the audience too.

Just now I don't want to talk about the Labour Party machinery and how it manifests itself in the City Chambers. People here know it's corrupt. In paying attention to certain issues you map that corruption and try and show what its effects on the community are or could be. There's an extension of this point: local politics are a turn-off for a great many people, but the paradox is that struggle usually begins on your own doorstep. When you map corruption at a local level the network always spreads out the way. Paul Foot (another guest speaker at the event) has been involved in what's known as The Colin Wallace Affair, corruption at the highest level, on a parapolitical level, but his involvement had to start somewhere and as far as I know it started from a letter landing on his office desk. From that point on, at the risk of being presumptuous, I would be surprised to hear him say he followed any specific course of action, I would doubt whether there was any specific course of action — apart from keeping an open mind, and being as thorough as possible.

I'm reminded of Noam Chomsky who to some extent might be described as a 'self-taught' academic. About four years ago he gave a series of lectures in Nicaragua. During one discussion he was asked by a member of the audience about dialectics, about the dialectical method and its importance to him. Chomsky said he had never quite understood what dialectics was. Then he said to the person asking the question, but if it works for you then use it.

One of these simple truths: the more you look at it, the more complicated it gets. An aspect of what he means has to do with the idea that there isn't one unified theory which will explain everything. In fact that isn't even a possibility. Much of the revolutionary work he did in linguistics and the study of mind more than forty years ago concerns that very point. About the best we can hope for is being able to demonstrate that this theory works and that one doesn't. We might use a method for that demonstration, but other ones will come along. But as far as the world's concerned, the mysteries of the universe, there is no one system that can explain that. No *one* idea, no *one* person, none

of that sort of stuff. Chomsky is attacked and marginalised by the right, he's also attacked and marginalised by a few folk on the left, which is more interesting. Of course he's an American middle-class academic and that for some people's enough.

The official educational system didn't provide people like Harry McShane with their education either. Not then and not now. That's not its purpose. Its purpose is of course the opposite, it's designed not to educate. The 'self-taught' school exists in spite of the official one. The official educational system is part and parcel of the British state, a very crucial part of it. So we shouldn't be surprised to discover that it always seems to fail in educating our young people properly. It's the first stage in a lifetime process of state propaganda and disinformation, the earliest battle in the psychological warfare the state wages against the people.

It seeks to destroy our enthusiasm for learning. Instead of opening our mind it seeks to close it. When most working class people leave school they never want to see another book in their life. Reading 'seriously' is a form of punishment. Education itself is seen as punishment. You've got to fight to rediscover the excitement of learning. Anything you pick up is in spite of the system. Our kids have to steal what education they can. But what the state can't stop is your access to books. It tries to in different ways but it's doomed to failure in that one respect at least.

What I'm now stressing, in the spirit of Harry McShane and his friends and comrades, is not the importance of ideas, but the importance *of the exploration* of ideas. Because that's at the heart of radical politics. And people like McShane and his peers, such as John MacLean, they knew that and lay the utmost stress on it. You take nothing on trust without making inquiries, especially if it carries the label "official". And ultimately it doesn't matter if this idea is 'left wing' or 'right wing'. If it's 'official' you've got to be wary. You have to see for yourself whether it's true or not. If it works use it. If it doesn't then dump it. There's no authentic movement without that central critical element. I haven't read a great deal of John MacLean's writings but like so many of the great radical thinkers and activists in what I have read he is, first and foremost, a *critical* mind.

The power of radical ideas is one of the strongest weapons we have on the left. And we don't have many. But as soon as we stop

exploring them we're as well burying them — and Highgate Cemetry is as good a place as anywhere, because that's all it is, a cemetry. The right wing have very few. And that's one sound reason for its continued success. Its only goal is to keep power. All its wealth and resources go toward that. It strikes me too that the current controversy about the so-called entry of the so-called far right into the Tory Party underlines the point. The far right (in this case the authoritarian as opposed to libertarian right) attempts to explore ideas, they're not good ideas, in fact they're only about the use of power. But they have been exploring them. And the pragmatists know that's dangerous. It weakens the power base. Like Neil Kinnock and the rest of Her Majesty's Most Loyal Opposition the far-right also has a function, they too are servants of the state. Servants are allowed to think for themselves, but not to give voice to these thoughts in public.

At one time I used to think the state would hang onto the monarchy at all costs, but I don't any longer, I can envisage them dumping that too, sooner or later, not quite in the way Margaret Thatcher got dumped, but it's horses for courses, whatever's necessary, in order to keep power. Thatcher was fine when she played the game, fine for that period in the mid-1970s into the mid-1980s when reaction needed an enforcer, when the Russian bogey needed life breathed into it. A strong leader. But once she started chasing ideas she became dangerous. She rightly describes Major as a man without ideas. But she is way out of line to attack him for it. A person without ideas is exactly what the authorities require at that level. And to that extent, unless he changes he will be a Reagan-figure, a puppet. Those in control of the state much prefer that. Certainly at this time they do and Margaret's got the message, just as the far right will also get the message, in one way or another, for the time being at least.

"One hallmark of an oppressed society is the lack of public meeting places. In many countries in the world the state considers the church 'dangerous'. But in these countries you also find that the public have no other places available. It isn't so much that religion is a threat: the threat comes from people gathering together. If talk is cheap dialogue is dangerous. It leads to action. This is why in times of domestic crisis the state won't allow groups of folk to hang about on street corners; 'mobs' of more than three people having a conversation on on the pavement are moved on by the police,

otherwise they get done for 'loitering' — with intent to start a
revolution.

The authorities prefer a situation where the only meeting
place is the pub. By the time you've talked your way through the
problem you're too drunk to do anything about it.*

We were aware of this in the Campaign to Save Glasgow
Green, the very place where people have gathered to air and
address their political grievances. Glasgow Green is not only a
prime site for the cash profit brigade it's also dangerous, it repre-
sents a threat to local security, it's where people meet and talk. And
similarly the Citizens' Rights Office and the Unemployed Workers'
Centre in Edinburgh, or the tiny Clydeside Action on Asbestos
office down the Briggait, plus all the rest of the community-based
advice-centres that the Labour Party are trying to close down,
implementing Tory strategy, they aren't just places people go for
help, they are places where people meet. And when people meet
they communicate, they explore ideas.

Ideas are not closed entry systems, they aren't icons. You
don't knock them down for the sake of it but you've got to chal-
lenge them, and be allowed to challenge them. If they can stand the
light of day then fine. But you can't afford to take them on trust.
Because that's the first target your enemy goes for. If you don't have
your theoretical base sound you're as well fighting with a bag of wind,
the bag might be big but it's full of air, a safety pin bursts it.

There's a stage where the leadership has the power. But what
is the power except the 'idea'. Yes, and the 'idea' is not to be chal-
lenged. Yes, and neither's the leadership. You see then how the
closed system operates. To get to the leadership you've got to get to
the 'idea'. But the only way is *through* the leadership, because they
hold the 'idea'. And you're supposed to accept without question.
And I'm not just talking about Pat Lally's control in the City Cham-
bers, or Kinnock's control at national level obviously although the
party machinery that pushes people so morally and politically
bankrupt as that into power illustrates the point. It's a system that
only works by placing the greatest store on minds that are not
allowed to question, and as events in Eastern Europe have shown
all too clearly, sooner or later people get to the bottom of it, then
they reject it. And at some point a quasi-socialist totalitarian state
will find there is nothing to do except hand over the key to the

51

cabinet. But of course the situation in Eastern Europe isn't the same as here — quasi-socialist totalitarianism, which we haven't experienced — although if you live in Glasgow you've been getting an insight into it for quite some time now.

But on the radical left we have a situation where groups, parties and factions are divided by ideas and too often they waste their time polishing them up before sticking them back in the display cabinet, then locking the door. About myself for example, people in the S.W.P. will say, why have him come and talk? Outside the S.W.P. people will say why is he talking on an S.W.P. platform? And tomorrow on the Federation platform at the anti-poll tax rally something of mine I think's going to be read and the same sort of comments'll come from people involved with *Militant*, and then from people opposed to *Militant*.* It's a familiar pattern.

And since this night is a tribute to Harry McShane, who was pleased to speak on the S.W.P. platform on many different occasions, it has to be faced up to that many of his friends are still angry about the way he was treated latterly. These things have to be confronted. If we don't then there's no chance of moving forward. But they can only be settled in dialogue. We can't afford to let dialogue become a lost art, not on the left, our networks and channels of communication have got to remain open.

It's not possible to construct truth out of one idea or one set of ideas, one individual or one set of individuals. Ideas don't belong to anybody. Every idea that there's ever been is shaped collectively, by the dead as well as the living. If we take one we don't have to take them all; and we can take part of one and leave out the other bits. If there's one thing worth reading in the works of Lenin or Trotsky or especially Marx, then it's the index. You don't have to go away and study all the writers and thinkers that they did. You just have to recognise that that is what they did. They *explored*. Nothing's sacred. That's not how it works. Ideas come from people and nobody's perfect.

*In fact, once the actor who read the piece had finished, the police were waiting for him and wanted to know his name and address.

Prisons

(a talk given at the Edinburgh Book Fair 1991)

What would happen if you went along to your local prison (or police station for that matter) and asked to gain regular access in order to judge whether or not the prisoners — or the prison officers — were living a life you can reconcile yourself with, given that the inmates are supposedly kept behind bars on our behalf, as members of the public-at-large, and that those employed to keep them there are employed on our behalf. What would happen if a majority of us did likewise, and decided that change was essential?

Anyway, whether we like it or not, prisons are a vital part of society, and perhaps we have a responsibility to know what goes on inside them, behind bars, especially when the visitors have gone. What does it actually mean to be a prisoner, what does it actually mean to work as a prison officer? Is there a better way? Given that Scotland has the highest proportion of young people locked up behind bars than anywhere else in Western Europe what sort of effect does this have on them, on their future, on their friends and families, the future of their friends and families and so on? What does it tell us about young people in Scotland, how we treat them, how society treats them, how the legal system treats them, how the police treat them? What does it tell us about Scotland itself, about what sort of society we exist in? There are any number of questions you like about any number of aspects of the penal system but at this point I want to stop because the topic is far too serious for far too many people to start with a premise that could be so flawed fundamentally.

And here I mean that the way such questions are usually raised imply not so much that change is possible, but that it has to

do with acts of will on our part as members of the public; even the fact — if it is a fact — that we can know and understand or not know and understand how the reality is behind bars, say for long-term prisoners, and their families and friends outside, who can themselves be victimised to an extent you sometimes find astonishing. I'm saying that the fact of this present discussion implies that we live in a society which allows us to be responsible, allows us to take part in the decision-making process in a meaningful way, the assumption being that we live in an open and democratic society. And unfortunately this is something we can't assume easily. Not only do I not assume it, I don't believe it: our society is certainly not open and it's only with some linguistic juggling you could describe it as democratic.

Is it really true, for instance, that the penal service operates on our behalf, the public-at-large, the people? Or does it operate on behalf of those who govern the people? Perhaps it operates for the benefit of those who control the operation, including the prison authorities themselves. Or perhaps it operates not on behalf of those who govern the country, but on behalf of those who remain in permanent authority, a body we might call the state — I'm now distinguishing between it and the government, I'm speaking about the people in permanent control. In this group we might include all sorts of civil servants in all the many institutions there are in this country, including law and order and the legal system, the military, the immigration office, the intelligence agencies, the Department of Social Security and so on, institutions which make up the infrastructural framework of society.

One reason why I was invited to take part in this discussion, from the platform, is because I wrote a play surrounding the last days of two men condemned to death; then as well some of the characters in the stories I write are close to that edge which ends in a prison sentence, other characters have or may have served time in the past.

I've got no direct experience of it myself, never having been in gaol. I have visited people in prison a couple of times but what goes on behind bars, when the cell door is locked on you not just one day but every day is something I find difficult to comprehend. The play I wrote was based on the end of the lives of two men condemned to death by the state for their political activities; they had attempted to overthrow the anti-democratic society they lived

in in order to create what they regarded as a just system of government. Through force of arms and a fine network of spies — a network developed earlier on in Ireland (some things never change) — through all of that the state easily put down the insurrection and chose these two men plus a third to set a terrible example, they executed them by hanging, and then had them drawn and quartered. Terror was one central method of state control, just as it is nowadays in so many countries in the world, including this one, where it's back on the increase again. In terms of the play I did what research I could, but it was difficult; so much is falsified or has gone unrecorded, some official stuff no longer exists and just about nothing at all concerning our own radical history appears in any of the history books that plug up the education system. Our weans learn how bravely such men fought in battles like Waterloo but not what befell the returning heroes, and the controls imposed on them by the state in the sure knowledge that their military servants could turn nasty when confronting the post-war domestic reality.

Leaving that aside, in fiction anything and everything is possible, including writing about folk who exist in an environment alien to your own which is what prison will be, although it's not only the environment that's alien, it's more than that, it's at the opposite pole of what existence actually means, it's the antithesis of what it is to be a healthy human being. The punishment prisoners receive is unfreedom, which for a few ends in death.

The state regularly imposes conditions which are not only anti-social but anti-human on people and as a member of the public-at-large I'm interested in what takes place under the pretext of being done on my behalf. Although I suppose I am more interested when it occurs in the normal course of events the situation of prisoners and their families and friends interests me too, and this in conjunction with the notion of state control, in its all hypocrisy and humbug, drew me to the subject of these two men. At that time, when I was doing the research, about 12 or 13 years ago, Barlinnie's Special Unit was going through a period of high profile, Jimmy Boyle and Larry Winters were then inmates. Both would perhaps have been executed had capital punishment been around when they were brought to trial. Neither was imprisoned for political actions but as regards the plight of the men in my play, the situa-

tion of Winters and Boyle was of more than passing interest, simply because each was involved in a life-sentence — which it proved, literally, for Larry Winters who died soon after in his cell and was a man that I managed to both like and respect purely from the one solitary occasion I met him. And when this occurs you are forced to confront the penal system and wonder about it, again given that it's supposed to exist on your behalf. I mean here even when punishment is, quote, justified and there has been no miscarriage of justice. It isn't enough just examining what goes on only on these special occasions. The penal system is central to this society and has a role crucial to the state and the control it exercises on the public-at-large, who are in many instances quite clearly seen as hostile witnesses if not the enemy. It is certainly true that in far too many instances the permanent state does not allow us the right to examine its institutions.

It would be good to see a comprehensive and authentic survey — assuming such a thing possible — on the subject, just to see what sorts of beliefs and assumptions the general public have about the penal system. Unfortunately for the prison service, through lack of information many of the public'll be tempted to base their opinions on their experience of the police. I include myself in that; it's hard to exclude it. I don't for one thing think it's too outrageous to suggest, for instance, that there will be people working in the prison service who disagree with 'parole', not in general perhaps, but certainly in relation to individual prisoners, just as there are members of the police force and others associated with them, who aren't happy with parole either, just as many want a return to capital punishment and many aren't happy with the jury system and think we would be better having 'law and order experts' (in the same sense as we have so-called 'terrorist experts') rather than members of the public fulfilling the role, maybe even moving towards a sort of Diplock court like in Northern Ireland under the emergency powers act where the authorities do away with juries altogether. Northern Ireland, of course, acts as a training or testing ground for all sorts of things. But I wouldn't condemn the police or prison staff and authorities for holding these opinions, and airing these opinions in public. That's part of what democracy's about, diversity of opinion, public debate, etc. I've also encountered police officials who refer to people taking part in political rallies and

demonstrations, as 'the rubbish' which is less easier to forgive. And like other people here today I also know on good authority of people who've received beatings by the police, and some have died. I don't mean this as a straight slag on the police and by association the men and women who work in the prison service and hope it isn't being regarded as such.

A friend of mine who is now in his early seventies but still politically active, got a call from two police officers recently because he hadn't filled in his census form; they told him he might end up in jail and he felt obliged to remind them they were actually the police and not the judge and jury. (The man had his case admonished in court.) And unfortunately that combined role has extended to inflicting the punishment and its ultimate extension, performing the execution. But it isn't the expression of uncontrollable anger which however much appals us is at least something the public must acknowledge as conceivable, given the situation, it's when the forces of law and order combine the roles of jury, judge, chastiser, and executioner, as a form of policy, albeit unofficial policy, that we confront the fact that many state institutions simply don't exist on our behalf at all. That in many cases the police force and prison service not to mention the military and intelligence agencies regard quote "offences", criminal and otherwise, as attacks on themselves, not attacks on the public, and not necessarily personal attacks, but attacks on the institutions of which they are a part.

But members of the permanent state are also members of the public, whether they like it or not, whether we like it or not, and if this was an open and truly democratic society then they would be accountable to us, the people, the public-at-large. One of the particular and maybe more plausible arguments put up by the permanent state in justification of what is in effect a straight attack on democracy is an old one as far as this country is concerned. People familiar with the work of such as Noam Chomsky, Edward Herman or the Scottish philosopher George Davie will recognise it immediately. It hinges on the increasing role played by the so-called 'expert'. The permanent state considers itself 'expert' and does all in its power to convince the public of that 'expertise', that it alone truly knows how to cope with the exigencies of state affairs, it does this by a process of mystification, by propaganda and straight

disinformation channelled through agencies like the media and education system.

Some people may be uneasy with what I'm saying, and whatever they see as the implications. I don't think it is easy to confront certain realities, one being that to describe this society as democratic is to perform a linguistic juggling act. And however much discussions like this one are of importance, and they certainly are important as far I'm concerned anyway, but if they are to be meaningful then they have to take place within a proper context, they have to be premised on the way things actually are in society as opposed to the received wisdom which emanates from the permanent state, on behalf of itself.

A Note on the War Being Waged
by the State against the Victims of Asbestos

*This was for a talk organised by the Socialist Teachers group of the E.I.S.
on the effects of the cuts in Government spending.*

When another round of cuts in government spending is an-
nounced it's aired publicly as part of a quasi political debate. It's not a
real political debate but the kind that takes place on television, and
when you switch off the television you switch off the politics. In this
debate politics and literature and the different forms of art as well as
sport, psychology, economics and philosophy and science and so on
are all kept in separate compartments. The question is discussed in a
theoretical way, if meaningful it has to do with strategy. Somehow the
idea that cuts in government spending can have a direct effect on the
lives of people gets totally lost in that posturing mire of pundits and
professional 'politicians'. The truth is that cuts in spending lead to
deprivation, hardship and suffering; for some people it means death.

As we know the government doesn't govern on behalf of the
people, it governs on behalf of those who control them. Govern-
ment is employed by the state to manage on its behalf and its
policies are designed to assist in the country's exploitation. In other
words the government sets the conditions by which the people are
robbed. Once a government endangers the state it gets the sack (the
removal of Thatcher and her team is a good example); and any
opposition party is a crucial part of government.

When Tory policy is government policy it still has to be
implemented and without the connivance of the Labour Party it
couldn't be implemented, it couldn't be put into practice. The
Labour Party and the mainstream Labour Movement connive with

the Tories; together they help destroy people's lives; without their support the cuts wouldn't take place, without their support the people wouldn't be robbed, their quality of life wouldn't be destroyed.

I want to turn now from the general argument to a particular aspect of it, in other to words to what actually happens to one group of people as a direct effect of the implementation of government policy.

Since the turn of the year in Glasgow at least 16 people have died from asbestos-related disease [around early March 1992]. The actual figure will be much higher. Nobody knows how high; these deaths aren't recorded properly. The people referred to were members of **Clydeside Action on Asbestos** and they came to the office seeking support and counsel. Many people remain ignorant of the cause of their illness, many won't have been diagnosed properly by the medical profession. Other victims never get to know that their deteriorating condition is a prescribed industrial disease, caused through negligence or straight exploitation, knowingly and cynically.

One of the dead was a senior teacher, a woman who died of mesothelioma at the turn of the year; mesothelioma is a cancer caused only by exposure to asbestos. Most victims have worked in the asbestos or insulation industry, in the shipyards, or the construction industry. The death of a school teacher may be unusual. But then again it may not. We can't tell because of the misinformation and disinformation surrounding the facts and figures. Once acquainted with the evidence those who deny there is a cover-up going on are arguing against that evidence. Perhaps they are on the payroll of the big asbestos multinationals or insurers, perhaps involved in the legal or medical profession, or working for the DSS; in other words those who deny it in light of the evidence are often benefiting, financially or through professional motivation, from the exploitation of these victims, most of whom will die, sooner or later, of asbestos-related disease.

Clydeside Action on Asbestos is a charity. Those who work there are volunteers, themselves victims of asbestos. They receive very little funding and almost no support from any official body. Trades union assistance is minimal and restricted to donations from individual branches. The group supply support and counsel to other victims, fighting on their behalf to secure disability benefit

and other entitlements from the DSS; they also help secure compensation from those responsible for their terminal illness.

An integral part of the struggle is getting the authorities to acknowledge the actual disease the victims are dying from. In some cases they are dead already and the fight to get it acknowledged is continued as posthumous claims on behalf of the family. If it isn't acknowledged officially then they won't receive benefit from the DSS and they won't receive compensation from the businesses responsible. So the authorities always deny a victim has the disease. These cases are 'tried' under Civil Law; therefore the burden of proof is always on the victim. And if the victim succeeds in proving s/he has the disease then the next thing the employers and authorities do is deny liability. Claims drag on for years. When a victim dies, under Scottish Law, the greater portion of the claim dies with them. Ultimately the only 'winners' apart from the asbestos industry and their insurers, are the legal and medical professions whose practitioners act on behalf of whoever pays their wages. An estimated one third of monetary compensation is all that remains for the victims once the legal profession finalise their accounts.

The school teacher referred to taught for thirty years. She was in her mid-fifties and had been diagnosed a victim some 14 months before she died and had submitted her claim around that same period. Generally, from first diagnosis, a victim has a mean life expectancy of six months. This woman survived longer, as many women do. Most of the last months of her life were spent trying to prove she qualified for disability benefit from the DSS. A week before she died representatives from **Clydeside Action on Asbestos**, in company with the woman's husband, attended a Social Security Appeal Tribunal on her behalf, trying to get the authorities to admit that she could catch this disease while employed in her 'employed earner's employment' i.e. as a teacher. Before the posthumous claim is allowed by the DSS her employers will have to admit that she was exposed to asbestos while working for them. The woman died in January and still the claim hasn't been settled [June 1992].

It must be stressed that this is no exception to the rule. People trying to cope with terminal illness are forced to finish their days battling with the DSS. If they win that 'victory' (i.e. receive their just entitlements) then they battle on for compensation from those

responsible for their imminent death. It happens to almost every victim. In fact most of these people die of a disease that the authorities say they haven't got. The main stumbling block appears to be the teacher's former employer, Strathclyde Region (the largest employer of low-paid workers in the country). They are trying to find ways of showing that the woman was not exposed to asbestos while employed by them as a school teacher. In this respect Labour-controlled Strathclyde Region is proceeding in the same way as any asbestos multinational corporation, or any insulating, shipbuilding or construction company that has knowingly employed men and women to work at jobs where there is a risk of asbestos exposure. Strathclyde must obstruct this claim. If the Region accept liability, thereby allowing the DSS to pay back the disability benefit to which her family, as dependants, are now entitled, then they risk an eventual civil action for compensation. Not only that, they open the door for all employees and former employees who contract or have contracted asbestos-related industrial disease.

The DSS always insist that an employer confirms that a claimant was employed by them at a job where they were exposed to asbestos. Obviously very few employers will want to admit this; but that's how the system operates. And this is one explicit and direct method by which the government, through its agency the DSS, aids and systematically abets big business in relation to industrial disease and compensation claims, both by those who are dying and by the families of those who are dead.

The only sure way to fight against this and similar tragedies is from the ground upwards. It isn't a fight for politicians, nor for full-time trades union officials. It should be but it isn't. The official Labour movement doesn't recognise the struggle for what it is. So colleagues and fellow-workers of these victims have to assume the obligation, if for no other reason than that every worker is at risk, including teachers and lecturers and other professional people. This woman's claim is a test-case, it will set a precedent not simply for all teachers, but for all public service employees. The DSS have framed the rules and regulations extremely tightly, in an attempt to exclude all those not engaged in 'prescribed' occupations, i.e. jobs not directly linked to the asbestos industry.

There are practical things that can be done. The EIS and other unions, and/or groups within, can collate and disseminate infor-

mation on asbestos and asbestos abuse. Personal testimony of when and where there have been incidences of asbestos exposure can be compiled (including renovation and removal work from as far back as possible). Since 1975 Strathclyde Region maintains some 75 percent of its asbestos has now been removed. But the latency period on asbestos-related diseases can be anything from 10 to 50 years. Lists of asbestos-products that have been used during the past 44 years can be compiled. It sounds difficult but really isn't, for example science teachers will already know about asbestos wool.

The danger here is to seem like scare-mongering but this must be risked. It is worth remembering that on two occasions when asbestos was discovered in the Houses of Parliament the MPs demanded the place be shut down till it was removed. And the same thing happened in Parliament Square, Edinburgh just a couple of months ago. The politicians don't take chances; neither should anyone else.

Finally a monitoring system can be employed by the work force generally. And how many people within the education service, not only teachers but janitors and other auxiliary staff, have died or are suffering from respiratory ailments? Eighty percent of asbestos-related cancers are lung cancers. There is a history of wrongful diagnosis in relation to asbestos-related diseases. People are diagnosed suffering chronic bronchitis, emphysema, asthma, chronic obstruction of the airways disease, etc. Very few doctors take the time to examine the medical findings in relation to occupational histories of asbestos exposure. That's the way the state and the asbestos industry and their insurers prefer it. How many workers who have had to retire on medical grounds are entitled to compensation let alone the various entitlements related to prescribed industrial disease? How many of those are suffering from a disease they know nothing about? It is very important to monitor the health of colleagues and fellow-workers. Go down to **Clydeside Action on Asbestos** and they'll gladly furnish advice and information on the different aspects of asbestos use and abuse. The office is down by the Briggait, halfway between the City Mortuary and Paddy's Market.

On the Asylum Bill

This was for a debate organised by Amnesty International in Glasgow, February 1992.

This debate is headed *A Duty Dodged*, and asks if "the British Government is failing to meet its responsibilities to refugees?" It refers in particular to its obligations under the 1951 UN Convention. But it should be remembered that "a memo was leaked last September which revealed proposals from Michael Heseltine and David Mellor to a secret ministerial meeting on asylum that Britain withdraw altogether from this Convention". So we shouldn't regard that same UN Convention of 1951 as something the state sees as sacrosanct. Heseltine's justification for the secret ministerial meeting was the 'pressure on housing' created by refugees. "The Foreign Office proposed sending all asylum-seekers back to 'international camps' or 'safe havens' in their countries of origin, where claims could be assessed." They proposed this in the full knowledge of the mass murder that has taken place in 'international camps' and 'safe havens' from Beirut to Turkey.

This is not irresponsible, it's just government at its most ruthless; and questions to do with morality seem to me irrelevant, it's barbarism; and how can you argue morality in a such a context. I personally don't want to get bogged down in discussions on international law and its enforcement, sanctions and so on — everybody here has a fair idea of the way the major powers react to such things, and we also know how repressive states like Britain respond to its so-called responsibilities.

Every government has duties and responsibilities: to whom it's responsible is the only practical question. And a quick look at the way the British state treats its own people supplies an answer,

whether we examine the workings of domestic law enforcement, the immigration service or the Department of Social Security. We need quite a hefty pair of blinkers to suggest that the government sees its primary duty lying in service to the citizens of the country. At least we can define the question of responsibility in a negative way; we know to whom the British government is not responsible, the majority of the British population.

But this debate shouldn't degenerate into party slogans being hurled across the floor. The majority holding in Her Majesty's Most Loyal Opposition, i.e. the Labour Party, are quite content to play the race-card or whatever other card suits them. Labour was the party of government when the 1971 Immigration Act was introduced, and people like Roy Hattersley and others are not averse to using the same prejudicial, often racist, language as their Right Honourable Colleagues, their so-called Bitter Enemies on the other side of the House. On the question of duty and responsibility, the response of Labour to poll-tax nonpayers in regions like Strathclyde and Lothian seems to sum that up in a nutshell. I have no faith in any political party, not the SNP, not the SWP, the WRP, the SDLP or the RCP, not anybody — just to get that out the road.

But the primary reason why we shouldn't get bogged down in sloganising is this: if we do we'll be here all night without facing up to reality, the terrible horror confronting refugees, not to mention immigrants and migrants, both in Britain, Europe and elsewhere in the world; a horror that is difficult to imagine for many of the people present just now, and I include myself in this. The Asylum Bill, and the draft Immigration Rules, and the draconian draft procedural rules on Asylum Appeals is just one more aspect of that reality, the end result of which for thousands of people is further suffering, further torture; for some it will end in death. And I'm not referring to what happens when this humane and morally upstanding country of ours deports refugees to 'safe havens' or 'international camps' in the full knowledge of the horrors that await them, I'm referring to what will happen right here. Four months ago one asylum-seeker in Britain served what turned out to be a life-sentence. He was 32 years old. "He died of a heart attack while being restrained by prison officers, allegedly attempting to break free". He had been in prison less than a month, he had only been in the bloody country two months. Amasase Lumumba was his name,

"the great-nephew of the first Prime Minister of independent Zaire." Would he have died if he had been of the correct racial origin; would he even have been in prison? What if he had been a white South African, a white Australian, a white Canadian, a white New Zealander — a white Russian? Many of you won't have heard about his death, for some strange reason it doesn't seem to have been newsworthy enough for our fearlessly subservient media.

Unfortunately the direct and explicit relationship between racism and the state-violation of refugees, migrants and immigrants is not alluded to by many of those who oppose the government's vicious attack on asylum-seekers. And I include some refugee counselling groups in this.

"Malcolm X once said in a visit to this country: Don't wait until the ovens begin to burn" (my reference is an article on the New Cross Massacre in London by John La Rose). Every day of every week people are being arrested and imprisoned and deported under racist immigration laws. Throughout Scotland, the United Kingdom, right the way across Europe, people are being violated in the most brutal manner, economically, emotionally and also physically. Two years ago Ahmed Sheikh was murdered in Edinburgh — there was a memorial march a couple of weeks ago. He was a Somalian refugee, 21 years of age. I wonder if the gang of white racists who attacked and killed him were aware that he had been granted refugee status? Would this knowledge have made the slightest bit of difference? Is this a peculiar line of questioning?

People will be aware of the increase in racism that occurred during the Gulf War (or to be more precise, as Tom Leonard points out, during the mass bombing of Iraq and Kuwait), the racism that occurred both to refugees and to black members of our own population. So while we want to welcome refugees to this country we don't do so thinking of Great Britain as a 'safe haven', we welcome refugees in the knowledge of the reality that awaits them. Racism is everywhere in this society, from the football terracings to Number 10 Downing Street. And racism is at the heart of the Asylum Bill. It isn't the only thing — so too are authoritarianism, the control of population, the control of the movement of migrant workers and so-called 'economic' refugees — but racism lies at the heart of this bill.

Take a brief look not only at how potential asylum-seekers are treated, not only at how immigrants are treated, take a look at how

the authorities treat actual *visitors* to this country, not to mention ordinary seamen on shore leave. Even passengers in transit are not excluded from racial harassment; people stopping over in our international airports and seaports while en route to foreign lands are being 'detained', in some cases they get gaoled overnight so that they can't 'escape' from the travel reception areas. We're not talking about white people, you never see white people in these reception areas, not unless they're wearing some sort of uniform.

If the Asylum Bill and the racist immigration Laws are to be defeated — and they can be defeated — it will be done by public resistance, not by representation; it will be done through mass action, action by the victims themselves and by those who are willing to stand with them — *not on behalf of them*, but alongside them. It will not be done by working through existing structures, nor by working through government and state-funded bodies; such bodies wouldn't be funded if they were a threat. Peter Lloyd has already told U.K.I.A.S., (the United Kingdom Immigrants Advisory Service) that its funding will be withdrawn if it doesn't accept "the proposal to become the monopoly provider of advice in asylum and immigration cases"; in other words our morally upstanding government wants to become the sole advisory body to the very people it's violating.

And as far as the direct and explicit relationship between racism and refugee-violation is concerned, let's tune into BBC Radio 4 and hear Peter Lloyd himself, and I remind you that he is Minister for Immigration at the Home Office: "We can't have the whole of Asia and Africa coming to live in London." These were his actual words last November, a fortnight after the death of Amasase Lumumba, literally in the hands of the Pentonville prison officers. As a matter of interest, during the 'mass bombing of Iraq and Kuwait', "the International Red Cross protested at the use of Pentonville to house immigration prisoners and asylum-seekers." Needless to report it and other prisons are still being used by the immigration service.

The point I'm making on public resistance shouldn't just be regarded as a political opinion concerning the nature of democracy in this country. Obviously there is no democracy in this country, the closest we get is when the ruling classes put their heads together and decide now best they can exploit and be served by the

majority. I make the point on public resistance simply because there is no time for games and meaningless babble, let's leave that to Her Majesty's Most Loyal Opposition and the official Labour Movement. People are being abused, they are being tortured and they are being killed. And it's happening while we speak. They must be supported immediately.

Meaningful forms of solidarity can provide the difference between life and death. The victims themselves should resist being passive or quietist. How have other groups within the black community organised? The last 15 years have provided very useful experience in that respect, so too has the street organisation and mass action witnessed during the miners' strike and the anti poll tax campaign.

I'm not saying resistance can only occur on the streets; there are many fronts. The slow and painstaking work on the Bill itself, picking through the draft rules on immigration and Asylum Appeals, this work is crucially important. But we must be wary of laying too much emphasis on finding loopholes. When one is discovered the Home Office will do all in its power to seal it off. The same applies to mitigating or extenuating circumstances; the state will never concede these without a fight. The authorities resist the use of precedents at all costs. It is of paramount importance to Home Office strategy that whenever someone successfully defends against deportation the case is regarded as 'unique' and 'essentially different' from all other cases. You have to force them to concede, on each and every case. The state regards a 'mitigating circumstance' as a special sort of 'loophole' and will seek to extinguish it altogether. Until this point is grasped people who address problems to do with asylum, immigration and racism will fail, they will fail because they take it for granted that the British State is enlightened and fair and eager to correct moral injustice if only the citizens of the country point to where it exists.

It is also important that analysis of the European context is attempted. We have to monitor the Trevi Group, the Ad Hoc group, the Schengen Group and so. Knowledge must be shared. No one has the right to withhold information that may save lives and prevent immediate suffering. We have to start talking honestly and openly. The violation occurs now, as we talk. That's the reality.

Oppression and Solidarity

*In May 1991 I was asked to deliver a talk around the subject of language,
culture and oppression for a night organized by the **Friends of Kurdistan**
(in Edinburgh); beginning from my own country which is Scotland, then
widening it out to finish on the situation facing the people of Kurdistan.
I've since developed the arguments; added much and subtracted much, for
meetings organised by among others the **Friends of Palestine** (in
Glasgow); **European Action for Racial Equality and Social Justice** (a
day conference in Southall, England); a discussion on racism in Britain
for a fringe meeting attended by black members of NALGO whose annual
conference took place in Glasgow in early 1992; the talk for **Amnesty Inter-
national** — included elsewhere in this collection — also enters this category.*

*It was a difficult experience back in Edinburgh. I don't talk without
writing the talk, and the talk was written. So there was no turning back,
even when I knew I had misjudged the audience. It was held in Edinburgh
University, and I had been expecting to speak mainly to students, but it
turned out there were very few students. In fact there was a fair propor-
tion of Kurdish people in the audience, most of whom were refugees. As
the night wore on it became apparent that political divisions existed
among them but no room was allowed for that side of things, no room was
allowed for authentic debate; maybe for the sake of a united front, maybe
because one side controlled the meeting — and the fact that the platform-
speakers, including myself, went on far too long. But I used my experience
of the evening to explore here and elsewhere the problems of offering
solidarity. So the piece that follows is an amalgam of talks I was asked to
give in contexts that might be described as alien to a white middle-aged
Glaswegian atheist protestant-bred male writer and father of two mature
daughters, who spent his early years in Govan, Drumchapel, Partick and
Maryhill.*

Article 18 of the Statutes of the Human Rights Commission
states that

> Certain ethnic groups are well treated by the
> dominant nations only to the extent that these
> groups accept abandoning their culture, their
> mother tongue, their history and their literature, in
> other words to the extent that they accept assimila-
> tion. We have a duty to encourage these ethnic
> groups to oppose assimilation, to develop and
> enrich their mother tongue, their literature and their
> culture. Only in this way can world culture de-
> velop, enrich itself and serve humanity.

which is fine as far as it goes, but I always wonder who the 'we' are.
The one thing I do know is that this 'we' never refers to the oppressed
and suppressed groups under discussion. They aren't so much the
subject of Article 18 as the object. They don't get a say in the matter .
Things get done to them. The 'we' of Article 18 have a choice: they can
treat oppressed groups well or not well; they can encourage or not
encourage . But no matter what that 'we' decide, it's their decision. The
rest of the world have to put up with it.

Article 18 of the Statutes of the Human Rights Commission
is, to my mind, as good a definition of western liberalism as you'll
find. From pronouncements such as this you can tell why European
civilisation has produced so much theology and philosophy;
philosophies of action and non-action; all these religious and moral
debates about individual and collective obligations, social and
otherwise; reasons for and against personal responsibility; an entire
edifice of educational and social structures designed to deal with
whether 'we' have a duty do this that or the next thing. Not de-
signed to perform these 'duties ', just to deal with the question of
whether 'we' have them or not, as an adjunct to 'our' continuing
exploitation and ruthless destruction.

It could only happen within a hegemony, where one commu-
nity has assumed power and has absolute control over other
communities. Communities under attack never have these particu-
lar ethical worries, they just find ways of defending themselves.

It should go without saying that any culture, history or literature is valid. Or any mother tongue. Let's call it Language; even using the term 'mother-tongue' in this imperial context somehow renders it invalid, an inferior 'salt-of-the earth' type thing. It should be an obvious point that we can't use terms like superior or inferior when we speak about cultures and languages, not unless we're willing to use these terms of actual peoples. If we feel happy about describing peoples as inferior then by all means we can use these terms when we speak of their cultures or languages.

Of course in our part of the world these so-called obvious points aren't recognised as obvious at all. Not only are they not recognised as obvious, our society is premised on the opposite view; our society is premised on the 'fact' that one culture *is* superior to another, that one language *is* superior to another, one literature superior to another, one class superior to another: that one people is superior to another. That's the fundamental premise which sets the structural basis of our society, it's endemic to it, it informs everything within it, from law and order to education, from health to housing to immigration control. And because of that when, for example, racist violation takes place on the streets it is entirely consistent that it should do. If the state is racist why should we act as though racism on the street is some sort of aberration? We live in a racist state so it's consistent. Why should we act as if it's a kind of social phenomenon?

But when we talk about the hegemony of English culture we aren't referring to the culture you find down the Old Kent Road in London, we aren't talking about the literary or oral traditions of Yorkshire or Somerset: we are speaking about the dominant culture within England; the culture that dominates all other English-language based cultures, the one that obtains within the tiny elite community that has total control of the social, economic and political power-bases of Great Britain. And leaving aside the U.S.A.'s sphere of influence, this is also the dominant culture throughout the majority of English-speaking countries of the world.

There is simply no question that by the criteria of the ruling elite of Great Britain so-called Scottish culture, for example, is inferior, just as *ipso facto* the Scottish people are also inferior. The logic of this argument cannot work in any other way. And the people who hold the highest positions in Scotland do so on that

assumption. Who cares what their background is, whether they were born and bred in Scotland or not, that's irrelevant, they still assume its inferiority. If they are native Scottish then they've assimilated the criteria of English ruling authority; if they hadn't assimilated these criteria they wouldn't have got their jobs. Exceptions do exist but exceptions only make the rule.

So of course Scotland is oppressed. But we have to be clear about what we *don't* mean when we talk in these terms: we don't mean some kind of 'pure, native-born Scottish person' or some mystical 'national culture'. Neither of these entities has ever existed in the past and cannot conceivably exist in the future. Even when arguments involving these concepts are 'rational', they can only be conducted on some higher plane. And it's always safer for human beings — as opposed to concepts or machines — when this higher plane is restricted to mathematics, theoretical physics or logic (or else religions that insist on a fixed number of odds). The logic of this 'higher plane' seems forced to generate a never-ending stream of conceptual purity to do with sets and the sets of sets; and the sets of the sets of the sets of sets; and the set of the sets of the sets of all sets.

Entities like 'Scotsman', 'German', 'Indian' or 'American'; 'Scottish culture', 'Jamaican culture', 'African culture' or 'Asian culture' are material absurdities. They aren't particular things in the world. There are no material bodies that correspond to them. We only used those terms in the way we use other terms such as 'tree', 'bird', 'vehicle' or 'red'. They define abstract concepts; 'things' that don't exist other than for loose classification. We use these terms for the general purpose of making sense of the world, and for communicating sensibly with other individuals. Especially those individuals within our own groups and cultures . When we meet with people from different groups and cultures we try to tighten up on these loose, unparticularised definitions and descriptions.

If you happen to be a Scotsman in a Scottish pub and you get talking to another Scottish man and you ask where he comes from you don't expect him to say 'Scotland ', you expect him to say 'Glasgow' or 'Edinburgh' or 'Inverness'. And if you're a Glasgow woman in a Glasgow pub and you meet another Glasgow woman and you ask where she's from you expect her to say 'Partick', or 'the Calton', or 'Easterhouse' or whatever. And if you're a Dennistoun man in a Dennistoun pub and you meet another

Dennistoun man and you ask where he comes from you don't expect him to say 'Dennistoun', you expect him to say 'round the corner' or 'Alexandra Parade' or 'Onslow Drive' etc.

A white working class guy got into an argument with a black middle class guy, a writer who had been doing a reading then during the follow-on discussion spoke of the historical culpability of white people, in relation to black people. It was quite brave because this was in Glasgow and the audience was 95 percent white. The white working class guy lost his temper and called him a black bastard. He was out of order to do so, and there isn't any excuse. But the black guy was also out of order. Both were wrong. There is a simplistic, generalised version of history which offers a sweeping account of the inhuman savagery perpetrated on black people by white people. There is a tighter version wherein the inhuman savagery is perpetrated by white peoples. An even tighter version concerns the inhuman savagery perpetrated on black peoples by white peoples. And so on. There is also the daily abuse and violation experienced by black people that is beyond anything white people can comprehend. There is also the day-to-day horror of existence experienced by a great many white Glaswegian people that a great many black people, including this particular black guy (who is an academic as well as a writer) have no conception of, and his blanket use of black and white, in context, served only to indicate his intellectual myopia about the everyday brutalities the British state perpetrates on sections of its own people, its so-called white brothers and sisters.

Wherever you look either at home or abroad you find cultures under attack, communities battling for the right to survive, often literally, where the fight for self determination means not only putting your own life on the line but as with the situation facing far too many people, it's risking and endangering the lives of your people and your family and your friends and your children. This is a war that's being waged and engaged on countless fronts. And these heavy defeats will continue until authentic and meaningful, honest dialogue starts occurring between the countless communities and peoples under attack.

In an interview with Dr. Ismail Besikci — held while he was awaiting trial in a Turkish prison in 1990 — he referred to the prosecution of the PKK (the Kurdistan Workers Party) which took

place in Germany the same year and reported on the "secret agree-ment between the NATO alliance and Turkey in relation to Kurdistan". Covert deals are always being done of course. This one means the Ankara government are entitled to do anything they like under the heading Rooting Out The PKK. For the actual people in Turkish Kurdistan it means they would rather flee across the Iraqi border than remain at home, they would rather confront Saddam Hussain's forces than stay and face the Turkish authorities.

> About 15 years ago a group of Kurdish students published a tract demanding that incitement to racial hatred be made a punishable offence and were charged with having claimed that there was a Kurdish people, thereby undermining national unity. They published the tract in response to various anti-Kurd threats made publicly from right-wing sources, including one nationalist journal implicitly threatening the Kurdish people with genocide. Meanwhile for the past 70 years the authorities have sought to destroy everything which might suggest a specific Kurdish identity, not just in Turkey but in Iraq, Iran and Syria. Different theories about nationhood have been constructed, essentially 'to prove' the non-existence of the Kurdish people, that they are not and never have existed.

The Palestinian people have their own stories. There are similarities between their situation and the one faced by the Kurds, but also dissimilarities. And the same thing applies to Punjabi people, Bangladeshi people and others from the Sub-Continent. The Asian and British-Asian peoples in Southall, like the different black communities throughout the country, are of course very aware of that. But so too are other communities under attack. There exists a support group for victims of asbestos whose central office is in Glasgow — where the incidence of asbestos-related terminal disease is nearly eight times higher than the U.K. average. Fifteen members of our group have died since the turn of the year [at the time of writing, around early spring of 1992]. I'm talking about

ordinary people working in ordinary conditions that ultimately killed then.

There is constant pressure on this support group. They receive no help from the official Labour movement, not the S.T.U.C. and not the Labour Party; not from any left wing party or group. They exist on donations from victims and sympathisers. Their major battles are against lawyers and the legal system, doctors and the medical profession; insurance companies and the asbestos industry, and one primary arm of state control, the Department of Health and Social Security. The British authorities always deny that the asbestos these victims were exposed to is at the root of their various, essentially fatal diseases, contracted through no one's fault but that of their employers who knew the danger but didn't tell them, often in direct contravention of government legislation, knowingly and cynically.

Even in Glasgow where around 20,000 people have contracted asbestos-related terminal disease since the end of 1945 very few people are aware of the reality of the nightmare faced by their neighbours and relatives, a nightmare that will become worse, and is not reckoned to hit a peak for at least another generation. The state distorts and disinforms. Side-by-side with the asbestos industry and the big insurers the authorities stop the information process, dishing out their propaganda. So most victims die of a disease the state say they haven't got. And as long as they deny the disease that's killing these thousands of people throughout the country the D.S.S. avoids having to pay out the disablement allowances and entitlements due to the victims. They avoid the people of the country knowing the full horror of a tragedy that could have been averted, given that those who perpetrated the tragedy — the asbestos multinationals — have been in full cognisance of the deadly nature of asbestos fibre, at least since the 1890s, while continuing to stuff our schools, factories and hospitals full of it.

Activists within the black communities here in Britain will soon pick up on the *general form* of the asbestos struggle. It's only in the last 10 years, in the wake of the New Cross Massacre (as John La Rose and others point out) that the state has conceded racism might be a motive in violent assault and murder. Even so they fight tooth and nail to deny it on each and every occasion. Just as *each and every* victim of asbestos-related industrial disease must fight to

demonstrate the cause of his or her imminent death, so too must a victim of racist violation fight to demonstrate that the people responsible for the violation were motivated by race-hatred.

No life or death struggle takes precedence over another.

Speaking with folk from different parts of the colonized and otherwise oppressed world, and with folk from within the different black communities and the different groupings here in Britain, one crucial problem lies in being honest with one another.

At some point people from overseas have to appreciate why many left wing, sympathetic people in this country just look nonplussed, embarrassed or depressed when asked to send off letters and petitions to Labour Party politicians and Trades Union officials. It's not that making representation to our elected and constitutionally attested-representatives might not be a good move, as far as *your* particular struggle is concerned; but within my struggle, here in Glasgow, within the context of its culture(s), such a move is absolutely worthless, a waste of time and resources — something akin to a contradiction in terms. That's my opinion though it rarely gets expressed, for at least two reasons, the first of which is dubious; I don't like being presumptuous. The second reason is that *you* have said such a move is crucial. And I'm aware or should be aware, that a decision made by those involved in one struggle is determined ultimately by its own context, that one solitary compromise, even with ruthlessly brutal states like that of the British, South African, Turkish, Israeli or U.S.A., may save hundreds, even thousands of lives. When a compromise like that needs to be made it cannot be made outwith the context of that struggle and that struggle alone. This doesn't mean only those born and bred within the culture of that struggle have the right to make such decisions. But generally it does mean that. So when an outside group or community seeks support in an approach to our domestic ruling authority, generally, we have an obligation to go along with the request, no matter what our reservations.

It is basic that the struggle for human rights is shown solidarity by those engaged in other struggles. A too rigid adherence to one line or idea or theory is a hindrance. More often than not this rigidity just indicates an unwillingness to accept that particular struggle in itself; an unwillingness to accept what should be the inalienable rights of those engaged within that struggle, the right to

fight as they see fit, in a context that ultimately is theirs and theirs alone. There's nothing more ridiculous than these so-called radical left-wing parties coming along to some demonstration or protest apparently in solidarity, then spending their time arguing with the people out doing it on the street, about the theoretical incorrectness of their ideological approach, their lack of awareness of 'the international context'. I'm reminded of that one about the guy selling — I can't remember — *Newsline* or *Militant* or the *Morning Star* or *Living Marxism* or *Socialist Worker* or the *Workers' Hammer* or whatever the hell, at the time of the printworkers' battle with Rupert Murdoch (and the British state) a couple of years ago. A small group of workers had overturned a car in preparation to defend themselves against the forces of law and order, the comrade boys-in-blue, and this guy goes up and tries to tell them the Tories are the class enemy while at the same time forcing his newspaper down their throat.

But that doesn't mean we give up discussion and go in for blanket gestures of solidarity. Every struggle has a context. Every struggle has its own culture. The mistake we make is not discussing our differences, at the right time and the right place. For our part we have to take the bit between our teeth and make sure refugees and exiles don't mistake the official Labour Movement as the left in Britain, while at the same time allowing them to make representation in that direction. It's pointless being huffy. That also applies to those who ask support. You have to understand why many of us don't turn up or don't get invited to demonstrations of solidarity organised by the official Labour Movement. We all assume too much. We don't like being presumptuous. But we have to risk all that. It doesn't mean making decisions for other people and criticising them when they make a move that doesn't square with our own perspective — if we continue on that path then all talk of solidarity remains just that — talk; the sort of humbug you hear from party hacks everywhere.

I remind people here this evening, especially the ones who've got a copy of a recent Glasgow Keelie in their pocket, that the police confiscated as much of this issue as they could get their hands on. That's part of the reality of Glasgow in the early 1990s. The first thing to acknowledge is what's happening under your nose.

The Importance of Glasgow in My Work

(Talk written for gathering of folk involved at Extra Mural Department of Glasgow University creative writing groups, then revised for talk given at Thanet College, Kent)

In coming to terms with the title of this talk I could maybe start by saying why Glasgow isn't important. That might leave some sort of residue which has to do with the positive aspect, of why it is important, but it may be that there is nothing whatsoever 'special' about it, and I suspect this latter will be the case. I'm speaking personally here on how it relates to my own work, I'm not generalising. Other writers and artists might find it very important indeed.

Glasgow just happens to be the city that I was born within and where some of my family, some of my relations, some of my friends and some of my neighbours happen to live. I could have been born anywhere in the world I suppose. And wherever that chanced to be would have been equally unimportant, or important; perhaps even more important by which I mean that I could have been born into a society that didn't allow me to function as a writer with the freedom to write what I like. I could have been born in Southern Africa or Kenya, other parts of Africa, or I could've been born in a place like Iran, or Turkey, different parts of Asia, parts of South and Central America, parts of Europe. If I'd been born in a different part of the world, a different social and cultural environment, then the fact of that in itself might have been crucially important. But I landed in a place where it is still possible to be as free as you want as a writer, provided you restrict yourself to certain media — I mean that you've got to stick to prose and poetry; once you want to write drama, film, radio or television, and become involved with the media at large, then you're in trouble, you can no longer take freedom for granted, but I'll return to that later.

How to define being a writer. I'd like to use the term 'artist' in its general sense; an artist can be a poet, a novelist, a sculptor, a songwriter, a painter and so on. For myself being an artist comes second to being a person. If a person is committed to some project or other and the person also happens to be an artist then that person is an artist who is committed. This applies also where the 'project' the artist is committed to is social or political change. Artists have their own ideas and opinions on that. For some artists in other parts of the world, being committed to a political cause often requires they stop working at what they do best, their art; their perception of their place in that particular society doesn't permit them the 'luxury' — there are many instances of this, artists forced into exile and devoting themselves to the liberation of their country. They become organisers, activists, soldiers, with little or no time left for their own art.

Some might argue that artists in that situation would give more assistance to the cause by continuing work on their own art but these decisions must be seen as personal. There is no general principle as far as I can see. An artist decides for better or worse and does so in good faith.

From that you'll gather that I don't subscribe *easily* to the 'art for art's sake' perspective; in fact in its conventional usage it strikes me as quite a dubious proposition altogether. If ever there was a time when it was valid, which I doubt, then it lies in the past; nowadays, at best, it's an anachronism. But there is a sense in which I do subscribe to it.

Many contemporary writers are not only forced to leave their own place, the poetry, stories and plays they create are never published or produced there. They are in exile and their work is absent, it is suppressed, banned. It is this sort of fact that makes me feel a need to draw distinctions in the use of the term 'writer'. Otherwise we get bogged down, we have a kind of murky area where writers of the sort alluded to are somehow engaged in the same pursuit as those who write spy thrillers, westerns, Mills and Boon style romance, satanic horrors; whatever. This is why I prefer to employ the term 'artist' rather than writer. I'm not saying that by using the term 'artist' all the problems are resolved, but it does help; because writers in this latter group, generally speaking, aren't artists at all.

There is absolutely nothing I would want to say to someone like Jeffrey Archer or Harold Robbins or Stephen King or Frederick Forsythe. I don't regard what they do as being in any way similar to what writers of the kind alluded to earlier are engaged in. There is a

trivial level: but how long can you talk to somebody about things like tipex and propelling pencils, or the relative merits of wordprocessors or electronic typewriters.

This has nothing to do with 'high brow' literature versus 'low brow' literature. Nor is it simply the fact that the politics of the writers named strike me as beyond the pale; although that definitely does plays a part. It's just that I've nothing to say to writers who aren't committed. There are no areas at any intellectual level I want to enter into with them. It makes no difference whether these writers are from Glasgow or Johannesburg. Yet there remain a few I could find it possible to communicate with, in certain social settings, as long as it didn't happen too often: members of what I'll describe as the literary establishment. That's because they at least take the artform itself seriously, they approach it in an honest way. But when commitment, or what I mean by the term, looms into view — as it always does sooner or later — then the conversation grinds to a halt, or ends in social disarray. In that case I have much more to talk about with folk who aren't writers or artists but whose commitment leads them to live their lives in ways I approve.

This may sound very precious. That's a pity.

Okay, from there back to Glasgow and what I consider all-important: the freedom to write stories. But in coming back to Glasgow it should be kept in mind that Glasgow can be any other town or city in Great Britain, including London, Edinburgh, Cardiff, Cambridge, Newcastle or Ramsgate. I'd prefer not to refer to the United Kingdom since that includes Ulster. But even if you are an artist in Belfast and want to create from within your own socio-cultural experience there are certain things you're going to have to accept as we do here, perhaps especially as writers. By far the most important is censorship and suppression. I don't mean by this that you participate in censorship and suppression, you just acknowledge its existence. If you don't you're living in a dream world and should stick to writing fantasy: horror tales, bodice-ripping romances, cowboy and Indian stories; adventure yarns, cops and robbers, MI5-sponsored spy thrillers: all that sort of stuff.

At another level, unless willing to accept external constraints, you'll have to turn away from film screenplay writing, from television drama and from radio drama, because in these media you're forced into compromise, to an extent that leads to a position which

is ultimately dishonest. And I speak as somebody who has tried all three at one time or another. BBC and ITV; the film, theatre, newspaper and mainstream magazine industry; all exercise censorship, they collude in suppression. Poetry and prose fiction are the only free artforms available at present. I say 'at present'; the way things are going (with Clause 28/29 and maybe the blasphemy laws), this freedom cannot be taken for granted. It has always been a fight and things could get much tougher in future.

What debate there is on Salman Rushdie's novel *The Satanic Verses* over the issue of censorship and suppression is something of a red herring, to the extent that there has never ever been a time in the history of this country when censorship and suppression did not exist. But that point takes us into one of the few major industries left in Great Britain: Class.

My own background is as normal or abnormal as anyone else's. Born and bred in Govan and Drumchapel, inner city tenement to the housing scheme homeland on the outer reaches of the city. Four brothers, my mother a full-time parent, my father in the picture framemaking and gilding trade, trying to operate a one-man business. And I left school at 15 etc. etc. The kind of working-class background that can include relatives who have white collar occupations — even distant relatives who were 'school teachers'. Books were not unknown in my home and social mobility certainly existed as a concept. For one reason or another, by the age of 21/22 I decided to write stories. The stories I wanted to write would derive from my own background, my own socio-cultural experience. I wanted to write as one of my own people, I wanted to write and remain a member of my own community:

That advice you get in the early days of any writers' workshop or writers' group 'write from your own experience'. Yes, that was what I set out to do, taking it for granted. What I soon discovered was that this was easier said than done. In fact, as far as I could see, looking around me, it never had been done. If it had I could never find it. There was nothing I saw anywhere. Whenever I did find somebody from my own sort of background in English Literature there they were confined to the margins, kept in their place, stuck in the dialogue. You only ever saw them or heard them. You never got into their mind. You did find them in the narrative but from without, seldom from within. And when you did see them or hear them they never rang true, they were

never like anybody I ever met in real life. None of the richness of character you'll find in any cultural setting, any cultural setting at all.

How do you recognise a Glaswegian in English literature? He — bearing in mind that in English Literature you don't get female Glaswegians, not even the women — he's the cut-out figure who wields a razor blade, gets moroculous drunk and never has a single solitary 'thought' in his entire life. He beats his wife and beats his kids and beats his next door neighbour. And another striking thing: everybody from a Glaswegian or working-class background, everybody in fact from any regional part of Britain — none of them knew how to talk! What larks! Every time they opened their mouth out came a stream of gobbledygook. Beautiful! their language a cross between semaphore and morse code; apostrophes here and apostrophes there; a strange hotchpotch of bad phonetics and horrendous spelling — unlike the nice stalwart upperclass English hero (occasionally Scottish but with no linguistic variation) whose words on the page were always absolutely splendidly proper and pure and pristinely accurate, whether in dialogue or without. And what grammar! Colons and semi-colons! Straight out of their mouths! An incredible mastery of language. Most interesting of all, for myself as a writer, the narrative belonged to them and them alone. They owned it. The place where thought and spiritual life exists. Nobody outwith the parameters of their socio-cultural setting had a spiritual life. We all stumbled along in a series of behaviouristic activity; automatons, cardboard cut-outs, folk who could be scrutinised, whose existence could be verified in a sociological or anthropological context. In other words, in the society that is English Literature, some 80 to 85 percent of the population simply did not exist as ordinary human beings.

As a young writer there were no literary models I could look to from my own culture. There was nothing whatsoever. I'm not saying these models didn't exist. But if they did then I couldn't find them. It was only later on, after I had started writing, that I had the good luck to meet up with folk like Alasdair Gray, Tom Leonard, Liz Lochhead and others, through getting involved with a writers' group led by poet and critic Philip Hobsbaum, now Professor at Glasgow University, who at that time tutored an extra-mural class. I was about 25/26 by that time, but I was already writing and my first collection of stories was essentially completed prior to that. I'm speaking of what was generally available to readers, whether in bookshops or public librar-

ies. As some of you will be aware, these literary models do exist but you have to root them out. Tom Leonard has published an anthology of poetry entitled *Radical Renfrew*, written by ordinary men and women from the old Renfrewshire area (which included parts of Glasgow) from the French Revolution to the first world war — the vast majority of which is either rejected outright or gets no acknowledgment in mainstream literary circles. Tom Leonard had to excavate it. The old story: the prime effect of censorship and suppression is silence. Some mainstream critics want to argue that such poetry is of little merit. Whether that's true or not is irrelevant. But who or what group of individuals makes that decision? And by what authority?

So because of this dearth of home-grown literary models I had to look elsewhere. As I say, there was nothing at all in English literature, but in English *language* literature — well, I came upon a few American writers. I found folk whom I regarded as ordinary; here they were existing in stories, not as cliches, not as stereotypes. I was also discovering foreign language literature through translation; the Russians, the Germans, the French and others. I found literary models. I found ways into writing stories that I wanted to write; I could realize the freedom I had. I mean just the freedom other writers seemed to take for granted, the freedom to write from their own experience. Now I could create stories based on things I knew about; snooker halls and betting shops and pubs and DHSS offices and waiting in the queue at the Council Housing office; I could write stories about my friends and relations and neighbours and family and whatever I wanted. The whole world became available. Quite a heady experience.

It was after that came the other problems. Things weren't as straightforward as I thought. It hadn't dawned on me that there might be very good reason why these literary models didn't exist in my own backyard; yes, censorship and suppression. I quickly bumped against it through the elementary matter of my chosen artform, language.

You can't write a short story without language. That seems an odd statement. Yet received wisdom in this society demands it. Yes, they say, go and write whatever story you want, but don't use whatever language is necessary. Go and write a story for X amount of pounds; any story at all, providing you stay within the bounds. Not the bounds of decency or propriety or anything tangible; because that

isn't the way it works. Nobody issues such instructions. It's all carried out by a series of nudges and winks and tacit agreement.

Go and write a story about a bunch of guys who stand talking in a pub all day but if you have them talking then don't have them talking the language they talk. Pardon? I'll paraphrase: write a story wherein people are talking, but not talking the language they talk. By implication those in authority ask the writer to censor and suppress her or his own work. They demand it. If you don't comply then your work isn't produced. That's the way it is. That's the way it's always been. You land on the assembly-line of compromise the end result of which is dishonesty, deceit, falsity. Or else silence. Our mainstream media is full of silence. Why is it the better writers never work for the newspapers, for television, radio? Do you think it's because they prefer artforms like prose and poetry? Well sometimes that's true, but often it's just because every other medium is out of bounds.

There is nothing about the language as used by the folk in and around Glasgow or London or Ramsgate or Liverpool or Belfast or Swansea that makes it generally distinct from any other city in the sense that it is a language composed of all sorts of particular influences, the usual industrial or post industrial situation where different cultures have intermingled for a great number of years. In the case of my own family we fit neatly into the pattern, one grandparent was a Gaelic speaker from Lewis, another was from a non-Gaelic speaking family in Dalmally, up near Oban, another grandparent came from the east coast, the Macduff region; a great grandparent came from Northumberland. My wife is Welsh, but her people are Irish and Irish-Canadian stock including some whose first language is French. All of these are at play in my work, as filtered in through my own perspective, a perspective that, okay, is Glaswegian, but in these terms 'Glaswegian' is a late 20th century construct. Apart from direct experience I have access to other experiences, foreign experience, I have access to all the areas of human endeavour, right back from the annals of ancient history; in that sense Socrates or Agamemnon is just as much a part of my socio-cultural background as the old guy who stands in the local pub telling me of the reality of war as experienced by his grandfather in the Crimea War.

Let the Wind Blow High Let the Wind Blow Low

As in most countries whose historical role is subordinate to an imperial power the individuals who occupy the highest positions in Scotland do so on the assumption of its inferiority. This includes those born and bred here; it just means they've passed the assimilation test set by U.K. ruling authority. That's the way they retain power, by turning themselves into secondary members of the ruling group. Exceptions do exist but exceptions only make the rule. Some ingratiate from the outset. Others start by trying to fight the system from within. Gradually they get worn down by it.

A similar sort of thing happens when a man who's been a good shop steward takes a job as gaffer, thus joining the 'staff'. He tries to justify the move by arguing that one sympathetic member of the management team is 100 percent better than none. Ex-trades union activists always make the best gaffers. Management promote them if they can't sack them. One less activist on the shop floor. Plus he speaks the same language as the workers and performs a crucial function, acting as a buffer, as a go-between. Sometimes he works his way up the ladder. He does everything in his power to be fair, to interpret the rules and regulations as justly as possible. He clings on to that. But he won't breach these rules and regulations: instead they become sacrosanct; he becomes their guardian — a bit like a Sargeant Major. Both the workforce and higher management know better than to argue with him on procedural points of order. Higher management especially concede to him on such matters, benignly, with their smile of pseudo-resignation — they don't worry unduly since it was themselves who laid down the rules and regulations in the first place. In Scotland as I write this [a month after the 1992 General Election] the situation is at least interesting, but it's also disturbing. More people than usual

seem disillusioned by the U.K. political system. Seventy five percent of those who voted rejected the Tory national government. Many are extremely irritated by a state apparatus that allows such an unfair state of affairs. Some now accept the view that this particular political system is designed to perpetuate that and other forms of injustice.

Of course the U.K. political system has been around for more than a month and both in Scotland and throughout the U.K. as a whole there are many thousands of people who have done their best to reject it for a long number of years. Some have voted and some haven't. But the injustice, or illegitimacy, has been taken for granted. If a state is unjust why should we expect its political system to be fair and reasonable? Rejection of this particular state apparatus stretches back beyond the time the Labour Party leadership first sold out those who had placed their trust in them. Activists on the left have always fought the leadership of the Labour Movement which has been dominated by the old C.P. and the Labour Party, in and around the T.U.C. Optimists have worked to change it from within. Others have remained without. But whether within or without they have been excluded from power, isolated, left on the fringes.

The current debate on self determination has degenerated into one of these Bipartisan Issues that crop up every now and again on matters of National Importance, such as wars and acts of god. 'Pure' politics are forced to the sidelines. It becomes bad form to discuss one's differences. Unity is the watchword. It isn't a time for awkward questions. Those who persist are shown up as perverse, slightly bammy, crackpots — or occasionally as unpatriotic. What we discuss is what we are allowed to discuss. And as usual, on the run-up to the election, 'the country' was being bombarded from every direction that this was no time for neutrality. What is here meant by 'neutrality' is that either you are against your enemy or you're not. So tactical voting was allowed. The word was leaked from party headquarters, we could opt out of our party obligations, just so long as we screwed the nut and exercised that voting right to ensure a unionist/Tory-free Scotland.

Of course at every General Election the same voices tell us that 'neutrality is wrong', that we have an absolute and irrevocable duty to vote. Often it's a historical obligation: 'our forefathers fought for

it' or some such anti-existential crap. We must remember our duty 'to keep out the Tories'. Forget your political differences and vote. That message appears everywhere, including just about every front page of every so-called 'extreme' fringe-left party newspaper up and down the country. The interesting thing about General Elections is that instead of being political events they are the exact opposite. They are Bipartisan Issues, matters of National Importance. Unity is the watchword, not a time for awkward questions etc. etc.

State propaganda insists that the reason why at least 40 percent of the voting public don't vote at all is because they have no feelings one way or the other. They say the same the same thing in the U.S.A. where some 85 percent of the population are apparently 'apolitical' since they don't bother registering a vote. Rejection of the political system is inadmissible as far as the state is concerned. If you don't vote you're 'neutral', i.e. you don't 'have any politics'. Of course the one thing that does happen when you vote is that somebody else has endorsed an unfair political system. It doesn't matter who or what you think you've voted for. It doesn't matter what sort of protest you think you've registered. All that's irrelevant. A vote for any party or any individual is always a vote for the political system. You can interpret your vote in whichever way you like but it remains an endorsement of the apparatus. That's how the state interprets it and it's only their interpretation that matters. If there was any possibility that the apparatus could effect a change in the system then they would dismantle it immediately. In other words the political system is an integral state institution, designed and refined to perpetuate its own existence. Ruling authority fixes the agenda by which the public are allowed 'to enter the political arena' and that's the fix they've settled on.

Seventy five percent of those who voted at the General Election rejected Tory rule. What would have happened if they hadn't voted at all? How would ruling authority have interpreted the result? Probably as a landslide unionist victory. That 25 percent would have been transformed into a 100 percent no to self determination.

Landslide victories do occur in other countries. Often they defy all reason. Take for example election results from South Africa which aren't of particular interest to anybody outside of the television studios (and certain 'quality' newspapers whose proprietors have extensive holdings throughout the African continent). Unless

we turn off the Current Affairs' programmes on television we hear experts offering diverse interpretations, pundits discussing the implications of various bits of minutiae, e.g. why such an 'exceptionally high turn-out' took place. In some landslide election victories you do get these Exceptionally High Turn-outs. It's a peculiar experience listening to the pundits discuss the 'phenomenon'. We accept what they say in a kind of theoretical fashion while at the back of our mind lurks the knowledge that nine tenths's of the South African population aren't allowed to vote at all. An occasional expert will fly in from an Off-campus think-tank, referring to the 'South African model' as an Athenian Democracy, like pious Professor Paul from St Andrew's University who is thoroughly in favour of the system and wants it extended to all corners of the globe. By chance this same Expert on Politics is an Expert on Terrorism (the radical-extremist-left variety; in his no-nonsense writings you don't get any other kind). He pops up all over the place, both here and abroad, dispensing bull after bull with great pomp and gusto, mainly at the express invitation of other Athenian Democracies.

There is another type of landslide victory which is also peculiar since we know a murderous tyrant has just been voted back into power by the very people his murderous attacks have been launched against. We later discover that the Exceptionally High Turn-out took place in a vaguely alien context; those fit enough to make it to the polling booth were escorted there at the point of a gun. That sort of election result is rarely discussed on our 'current affairs' programmes. Even the BBC professionals are unable to conjure up a 'debate' (perhaps the phone-lines to St Andrews university were otherwise engaged).

This most recent General Election of ours also had an Exceptionally High Turn-out. Well the independence debate was a National Issue and more citizens than usual seemed to have felt it their duty to get involved 'where it mattered'. Let's put the polling figure at an exceptionally high percentage of 64 percent. This would mean that even those who didn't vote amounts to a far larger percentage than the unionist minority whose '25 percent' now rules the roost. Whereas the citizens who rejected the vote amount to more than a third of the entire voting population these roost-rulers are less than a sixth. And if you add the famous '75

percent' to the dissident '36 percent' you wind up with a mammoth 84 percent rejecting the UK political system and a paltry 16 percent giving it their endorsement. So there you are.

But what would have happened if the poll had gone differently? What if between them the Labour Party, S.N.P., and Lib/Dems had won every seat in Scotland? Not only that. What if the Exceptionally High Turn-out had been 100 percent of the entire voting public and every last one of them had voted against the Unionist Tories? A real Doomsday Scenario where because of the rest of the U.K. voting returns the Tories had still managed to hold an overall Whitehall majority! In fact what if . . .

Wait a minute. Would we be allowed to count this 100 percent as a 100 percent? Maybe we would have to take into consideration that the entire voting population of Scotland is not the same thing as the entire population of Scotland.

But for talking's sake let's assume Whitehall allowed us to regard this 100 percent of the voting population as a Voice That Speaks For All Scotland. What then? Would we have been allowed to interpret this as a mandate by U.K. ruling authority?

What does 'mandate' mean? A dictionary at random states: "A command, order, injunction . . . The instruction as to policy supposed to be given by the electors to a parliament or a member of Parliament". And under *Scots Law*: "A contract by which one person employs another to act for him in his affairs".

Returning to the hypothesis, wherein 100 percent of the voting population have rejected the Unionist Tories: in what sense would that situation have differed from the present situation? Answers to the Letters' Column of the Scottish qualities. The opposition parties were always going to have a mandate within Scotland anyway. And within this formation the Labour Party would hold an overall majority. Not even the combined forces of the SNP and the Lib/Dems would deny that. Under the first-past-the-post system it is inevitable that Labour holds the overall majority and that the opposition parties as a whole have a mandate. The Scottish people have given the opposition parties this mandate for years. And in exchange for accepting the mandate the combined opposition parties, spearheaded by Labour, have always demanded solidarity.

And here they are demanding solidarity once again. We don't know the precise form their demand will take. It seems the combined

leadership is 'waiting to see'. When this period of interregnum is at an end the People of Scotland will be instructed on the terms of solidarity required of them. We shall be advised of the proper way forward and that we must support this proper way forward at all costs. We shall be asked to retain our collective strength in a unified cross-party struggle, yielding not to easy options, nor to undignified posturing, nor to rash action, nor to impolite hectoring, nor to self righteous tubthumping; propriety will become the mark of the movement. When we march forward we shall march solidly, not breaking ranks; we shall comb our hair and wear smart leather shoes, dress in suits and shirts and ties — formal highland attire will not be frowned upon — this includes females and those from an ethnic background, for this way forward will unite everybody regardless of gender, race, creed or culture and will be led by a multifarious but patriotic group of notables: various party leaders, media personalities and constitutional experts; S.T.U.C. full-timers, representatives from the different religions — priests, ministers, mullahs, rabbis etc. — all striding arm-in-arm with bright-new-dawns glistening on our rubicund faces. We shall march on Westminster itself, the entire voting population of Scotland, and when we arrive we shall demand of U.K. ruling authority that they pay heed to our unified cry for self determination. Our demand shall be carried by our appointed representatives, appointed by and from the patriotic group of notables. With a dignity appropriate to this major historical moment of uniquely National Import our appointed representatives will accept an invitation to enter a smallish chamber inside the halls of Westminster. This invitation will have been extended by an assistant to an Under-Secretary of the Home Office Junior Minister-Without-Portfolio. But negotiation must begin from somewhere. Two members of Her Majesty's constabulary (bobby division) will step gravely aside, making way for this our All-Scotland representation. Inside the smallish chamber our select band will charge the Under-Secretary's assistant to return *post haste* to the Junior-Minister-Without-Portfolio that s/he may convey the gist of our demand: that Her Majesty's Government listens as it has never listened before. And if Her Majesty's Government does not listen why then our All-Scotland representation shall further remind Her Majesty's Government that a mandate exists, and what's more they have it, and they shall further

remind Her Majesty's Government that the entire voting population of Scotland does indeed speak for the entire voting population of Scotland which power is invested in themselves our representatives and that outside on the pavement, outside on the very pavement, beyond the iron gates of Westminster, at this moment in time, the entire voting population of Scotland is waiting, conducting themselves in a civilly obedient and orderly fashion. Our All-Scotland representation shall remind Her Majesty's Government of the meaning of the term 'mandate' as entered even in their own Shorter Oxford English Dictionary. And if they don't pay heed to us now then this is our very last word and we cannot vouch for our continued participation in the rules and procedures of state as laid down in 1707 by Their Forefathers in association with Our Forefathers, the then ruling authority of Scotland. And by the Gude Lord Jasus the entire voting population would just damn well carry on waiting right there on this pavement and see what Her Majesty's Government was going to do about that! And so what if it's a Friday afternoon and Her Majesty's Government has already fuckt off for a weekend in the country, we'll just damn well wait till Monday or Tuesday morning, even the following Monday morning, or the bloody Tuesday morning, we'll carry on waiting until they give us an answer, that'll show them the measure of our resolve.

Some Recent Titles from AK Press

TERRORIZING THE NEIGHBORHOOD: AMERICAN FOREIGN POLICY IN THE POST-COLD WAR ERA - by Noam Chomsky, preface by James Kelman; ISBN 1 873176 00 7, ISBN 0 9627091 2 3 (U.S.); 64pp two color cover, perfect bound 5 1/2 x 8 1/2; £3.95/$6.00 (co-published with Pressure Drop Press). Written in a rigorous but accessible style, this book is a short introduction and primer to this major thinker's work on U.S. foreign affairs: its causes, effects, and the interests it serves, both at home and abroad.

ECSTATIC INCISIONS: THE COLLAGES OF FREDDIE BAER by Freddie Baer, preface by Peter Lamborn Wilson; ISBN 1 873176 60 0; 80 pages, a three color cover, perfect bound 8 1/2 x 11; £7.95/$11.95. This is Freddie Baer's first collection of collage work; over the last decade her illustrations have appeared on numerous magazine covers, posters, t-shirts, and album sleeves. Includes collaborations with Hakim Bey, T. Fulano, Jason Keehn, and David Watson.

SABOTAGE IN THE AMERICAN WORKPLACE - edited by Martin Sprouse, illustrated by Tracy Cox; ISBN 1 873176 65 1; ISBN 0 9627091 3 1 (U.S.); 250pp full color cover, perfect bound 8 1/2 x 11; £9.95/$12.00; (co-published with Pressure Drop Press). Sabotage in the American workplace is as common as work itself. These stories present the other side. From employees at all levels of the workforce, the sabotage ranges from computer logic bombs to the destruction of heavy equipment.

THE ASSAULT ON CULTURE: UTOPIAN CURRENTS FROM LETTRISME TO CLASS WAR - by Stewart Home; ISBN 1 873176 30 9; 128pp two color cover perfect bound 5 1/2 x 8 1/2; £5.95/$10.00. "A straightforward account of the vanguards that followed Surrealism: Fluxus, Lettrisme, Neoism, and others even more obscure." *Village Voice*.

AK Press publishes, distributes to the trade, and retails mail order a wide variety of radical literature. For our latest catalog featuring these and several thousand other titles, please send a large self-addressed, stamped envelope to:

> AK Press
> 3 Balmoral Place
> Stirling, Scotland
> FK8 2RD, Great Britain